POSTCARD HISTORY SERIES

Allegany County

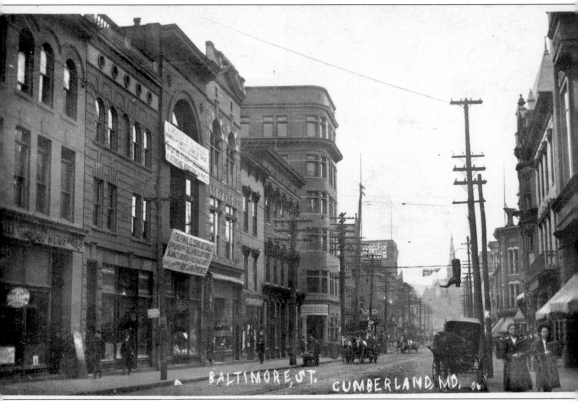

The site known as Cumberland was once called "Caiuctucuc," a name given the land by the Shawnee and which has been translated as "the meeting of waters of many fishes." Cumberland is located at the junction of Wills Creek and the Cohongaronta, which was the Shawnee word for the North Branch of the Potomac River and has been translated to mean "White Swan" or "Wild Goose Stream." Cumberland's nickname, "The Queen City of the Potomac," was given by the B&O Railroad because it was the second largest city on the Potomac River. Cumberland was also known as the "Queen City of the Alleghenies" because outside of Pittsburgh it was the largest city in the Allegheny Mountains. Once Maryland's second largest city behind Baltimore, the city's highest ever population of 39,483 people occurred in 1940. This 1906 view is of Baltimore Street looking west.

ON THE FRONT COVER: The Town Hill Hotel, depicted in 1928, was built in 1920 along the National Road, later U.S. Route 40, and is considered to be Maryland's first hotel built primarily to accommodate the auto traveler. The hotel had 23 rooms with transoms, which allowed for the flow of cool mountain air, and double beds with Beauty Rest mattresses, all for $2.50 per day. An overlook, billed as the "Beauty Spot of Maryland," looks down upon three states and seven counties. (C. E. Gerkins photograph.)

ON THE BACK COVER: Bituminous coal had been discovered in what is now Allegany County before the French and Indian War. At least three 18th-century maps document coal in the Georges Creek region. Although farmers worked small individual diggings prior to the 19th century, it would not be until about 1820 that coal obtained some degree of commercial importance. Georges Creek coal, such as that of the Koontz Mine, was prized for its steam-producing qualities, used in locomotives and steamboats and shipped worldwide.

POSTCARD HISTORY SERIES

Allegany County

Albert L. Feldstein

ARCADIA
PUBLISHING

Copyright © 2006 by Albert L. Feldstein
ISBN 978-0-7385-4381-0

Published by Arcadia Publishing
Charleston, South Carolina

Printed in the United States of America

Library of Congress Catalog Card Number: 2006934456

For all general information contact Arcadia Publishing at:
Telephone 843-853-2070
Fax 843-853-0044
E-mail sales@arcadiapublishing.com
For customer service and orders:
Toll-Free 1-888-313-2665

Visit us on the Internet at www.arcadiapublishing.com

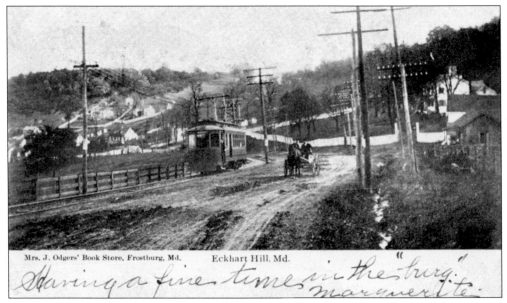

Mrs. J. Odgers' Book Store, Frostburg, Md. Eckhart Hill, Md.

A trolley car and horse and buggy descend the old National Road at Eckhart Hill. In 1806, construction of the Cumberland (National) Road was authorized by Congress. Its purpose was to connect the populated East and "navigable waters of the Atlantic" to the Ohio River. Construction began at Cumberland in 1811 and was completed to the Ohio River at Wheeling, Virginia (now West Virginia) in 1818, a distance of 132 miles. To a large extent, it followed the earlier Nemacolin's Path and Braddock's Road. This section is the nation's first federally funded and designed road and "interstate highway." Construction began on the National Road west of Wheeling in 1825 and proceeded to Vandalia, Illinois, its western terminus. In 1926, a national highway numbering system was established, and the National Road was designated as part of U.S. Route 40. It is now known as Alternate Route 40. Dedicated on August 2, 1991, Interstate 68 parallels much of the original National Road through Maryland. The sender of this 1907 postcard writes, "Having a fine time in the 'burg.' Marguerite."

CONTENTS

Acknowledgments 6

Introduction 7

1. Cumberland 9

2. LaVale 71

3. Frostburg 79

4. Georges Creek 97

5. Allegany County-wide 115

Acknowledgments

There are many people who helped me. I am deeply grateful to Ruth Hohing, John Rafferty, Dan Whetzel, Katherine Funk, Josephine Grabenstein Robey, Dave Gehauf, Maxine Prado, Tim Carney, Msgr. Thomas Bevin, Bob Bantz, Betty VanNewkirk, Daniel F. McMullen, Patsy Koontz, Regis Larkin, and Charles Goebel. I must also recognize those photographers and publishers who over the past 100 years created, produced, and preserved for posterity the historic images of Allegany County used in this publication: James Edward Grabenstein, Joseph Meyers, E. E. Thrasher, Ernest K. Weller, John Kennedy Lacock, C. E. Gerkins, Macdonalds Photographers, Phil Yaste Publisher, Neff Novelty Company of Cumberland, G. E. Pearce Drug of Frostburg, John W. Jackson Store of Lonaconing, J. T. Kooken of Piedmont, Kirkness Studio of Lonaconing, Rex News Agency, Triplett Studio, Edgar D. Growden, Thrasher and McCulley Studio, Eyerman Studio, G. W. McElfish, Mrs. J. Odgers' Book Store, Irwin Gilbert's Studio of Frostburg, and Curl's Camera Shop.

Since 1980, I have published 29 books, prints, and videotapes depicting the history of Allegany, Garrett, and Washington Counties, as well as nearby West Virginia. These works have focused upon such varied topics as historic postcards, newspapers, floods, grave sites, coal mining, railroads, community histories, and tour guides to historic sites. A recent effort is a political history poster entitled "Buttons of the Cause, 1960–2003: The Events—The People—The Organizations—The Issues," which is being marketed nationally, currently on exhibit and sale at the Smithsonian Museum of American History, and it can be viewed at my Web site, www.buttonsofthecause.com.

Pursuant to all this, I thank my wife, Angela, daughters, Natasha and Josinda, stepson, Michael Mulligan, and the good citizens of Allegany County who have supported and shared in my love of history throughout the years.

INTRODUCTION

Several Native American words and translations have been noted over time for the word Allegany. Most believe it is derived from the Delaware-Algonquin word Allegewi, which has been translated to mean "land of endless mountains" as well as "fairest stream." Some make note of the Allegewi being a tribe of the Susquehannock Indians. Others feel that Allegany is derived from the word oalikkanna/oolikhanna, which has been translated as "fairest or beautiful stream," while still others cite the Native American word Aliconie, which means "people of the mountain streams."

This book provides an in-depth overview within the space permitted of the numerous scenes and sites, many of which have long since disappeared, that portray the history and heritage of Allegany County. One thing I tried to do differently from previous works was to incorporate as many of the personal messages as I could from the back of the postcards. They're fun to read.

Allegany County is a selection of over 235 historic postcards with a good descriptive narrative touching upon the historical "highlights" of each scene. Obviously we had to do some painful editing as to what should be included, and our caption space was limited. I accept full responsibility for any omissions or errors in this work.

I hope you enjoy viewing these postcards as much as I have enjoyed compiling them for you.

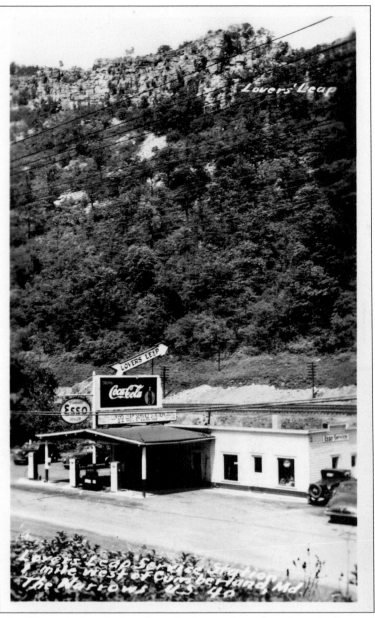

"The Legend of Lover's Leap" describes the love of an American Indian princess for a young English trapper named Jack. They wanted very much to marry, but her father, Chief Will, wanted his daughter to marry one of the British soldiers who was garrisoned at Fort Cumberland. Meanwhile, Jack had found a map to a silver mine located somewhere in the Narrows and offered the map to Chief Will in return for the hand of the princess in marriage. The chief promised they could be married if he was given the map, but once in his possession, he refused to allow the marriage. They tried to run away together, but Chief Will stopped them. A terrible fight began, during which Jack accidentally killed Chief Will. The Indian princess could never marry the man who killed her father, nor could she live without the man she loved. So arm in arm, they both walked up to the highest precipice in the Narrows and, from 1,000 feet atop Wills Mountain, leaped to the rocks and their death below.

One

CUMBERLAND

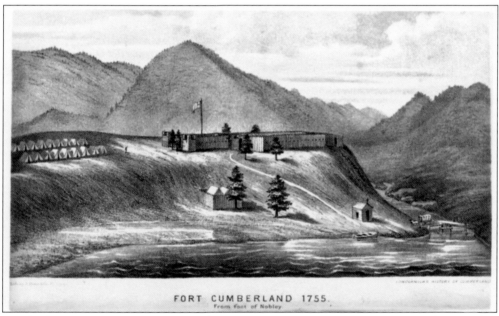

FORT CUMBERLAND 1755.
From foot of Nobley.

Cumberland's genesis stems from October 1749 when Christopher Gist, an agent for the Ohio Company, arrived at the junction of Wills Creek and the North Branch of the Potomac River to erect a stockade and trading post. In anticipation of the French and Indian War, a fort was constructed in 1754 upon the west bank of Wills Creek and named Fort Mount Pleasant. It was enlarged upon in 1755 and renamed Fort Cumberland by British general Edward Braddock after the Duke of Cumberland (the son of King George II and whose real name was William Augustus, 1721–1765), commander-in-chief of the British Army. By 1829, the fort had all but disappeared. It is from this fort the city, after being known for some years prior as Washington Town, takes its name. Cumberland was laid out in 1785 by Thomas Beall of Samuel, chartered by the State Legislature on January 20, 1787, and designated the county seat upon Allegany County's creation by an Act of the Maryland State Legislature on December 25, 1789.

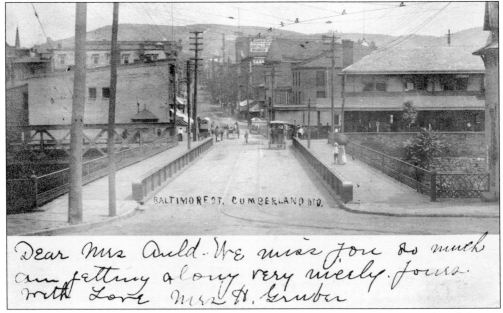

On the right of this 1906 view is the West Virginia Central and Pittsburgh Railroad Depot. Erected in 1887 near the corner of Canal and Baltimore Streets at the Wills Creek Bridge, the depot also served the Georges Creek and Cumberland and Pennsylvania Railroads. In 1905, the West Virginia Central and Pittsburgh was purchased by the Western Maryland Railroad. The depot was razed in about 1912.

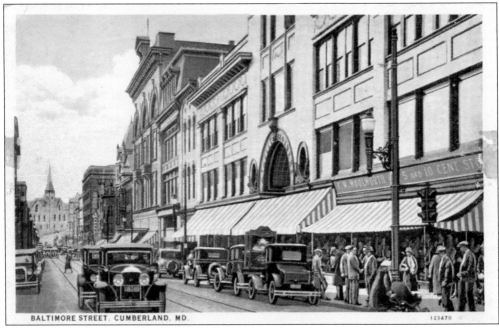

BALTIMORE STREET, CUMBERLAND, MD.

The sender of this July 13, 1930, postcard writes, "Elizabeth, arrived here OK. Scallops for dinner. Still don't know what they were. Some hills so steep that I thought Columbus was wrong. Love, Max." As portrayed here, F. W. Woolworth occupied the eastern portion of the building sometime prior to 1920 until 1950.

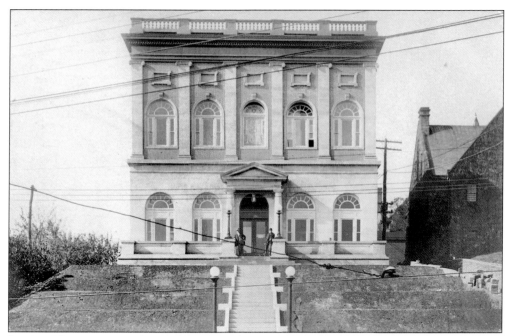

Depicted here in 1913, the Masonic Temple cornerstone was laid in 1911. The temple was built at a cost of about $75,000 and dedicated on November 12, 1912. Wall paintings by Cumberland's DuBrau Art Studio and elaborately carved furniture by local manufacturers H. U. F. Flurshutz and Son characterize the interior. Freemasonry in Allegany County can be traced back to November 1816, when the first lodge was established in Cumberland.

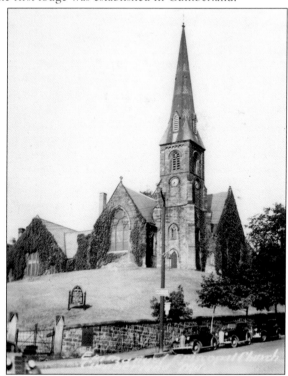

Emmanuel Parish was founded in 1803. The cornerstone for the stone Gothic Revival Emmanuel Episcopal Church was laid in May 1849 with the consecration held on October 16, 1851. It had eventually cost $18,000 to erect Emmanuel Church. The adjoining parish hall was constructed in 1901. In that same year, the entire property was enclosed by the existing stone wall. The church stands on the former site of Fort Cumberland.

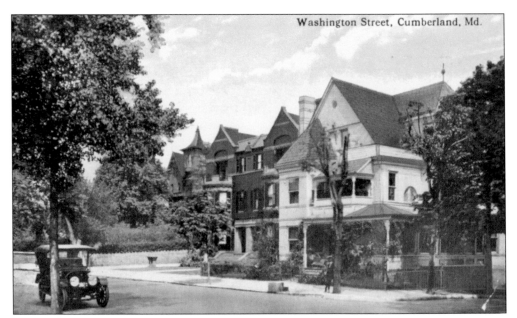

The sender of the 1921 postcard above writes, "Dear Aunt Mollie, my kitty is so big now. won't you come up for Christmas? Love, Willie." The Washington Street Historic District was considered the city's elite residential street at a time when Cumberland was at its economic peak. Washington Street was the home of the area's leading industrialists, businessmen, politicians, doctors, and lawyers. Here you find the styles that characterized American architectural history during the latter part of the 19th century. Included within the district are Federal, Greek Revival, Italianate, Queen Anne, Colonial Revival, and Georgian Revival architectural styles. The old Roman house, razed in the mid-1950s and now the site of St. Paul's Lutheran Church, is depicted on the far left. The 1906 postcard below depicts the 400 block of Washington Street looking west.

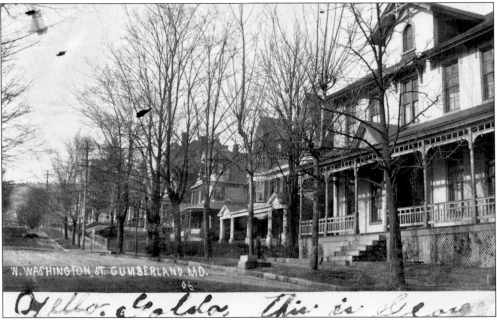

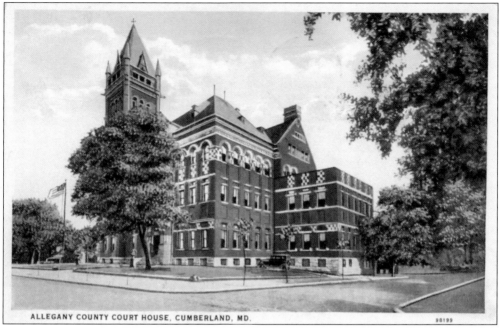

ALLEGANY COUNTY COURT HOUSE, CUMBERLAND, MD. 98199

The Allegany County Courthouse, seen above, was constructed during the years 1893–1894. It was designed and built under the supervision of local architect Wright Butler. Butler also designed the Masonic Temple and Liberty Bank building. Located on Prospect Square, the building was constructed at a cost of $97,000. Additions to the courthouse were later made in 1916 and 1925. Built in the Richardson Romanesque style, the courthouse is three stories high, with a steep hipped roof, four gargoyles at the tower corners, and a tower buttressed with round columns. A polychrome effect is achieved by the contrast of the brick walls with stone trim. Seen below, and second from the right looking east in this Washington Street depiction, is the historic 1890s Colonial Revival–style McKaig Mansion.

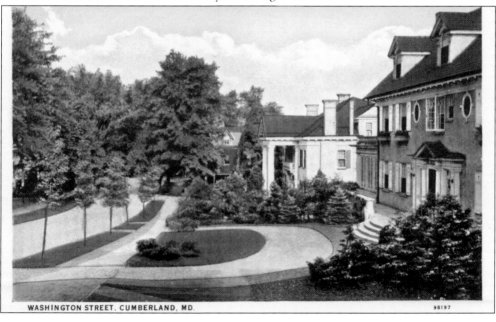

WASHINGTON STREET, CUMBERLAND, MD. 98197

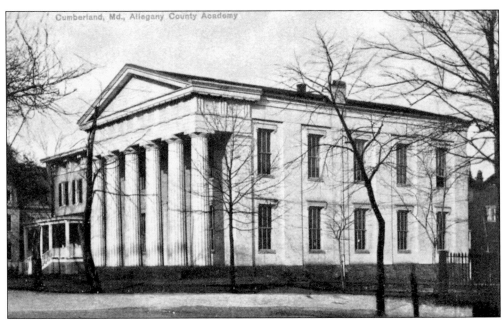

The first public school in Allegany County was incorporated in 1798 and popularly referred to as the Allegany Academy. In 1849–1850, a new Greek Revival–style school, shown above, was built at a cost of $5,000, and the Allegany Academy located to this site. After 131 years, the Allegany Academy closed in 1929, and in 1934, the building was leased by the county commissioners to the Cumberland Free Public Library. On June 19, 1934, the library was officially opened, and in 1960, the name changed to the Allegany County Public Library. Depicted on the left below in this card postmarked 1907 is the Magruder House. Originally built in 1855 and later enlarged, it is now home to the Woman's Civic Club. The sender writes, "This is the most aristocratic street in Cumberland."

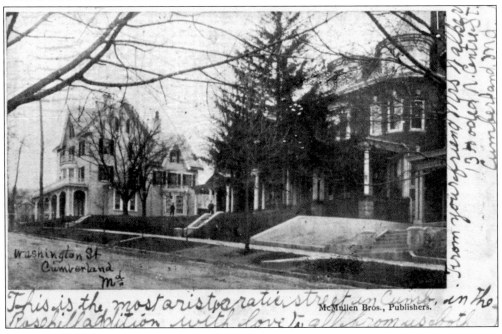

McMullen Bros., Publishers.

14

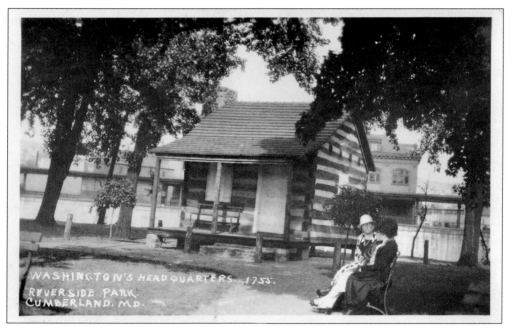

George Washington's Headquarters, seen above, is the sole remaining structure from Fort Cumberland. It was built in 1755, relocated outside of town in 1844, then donated back in 1921 and placed in Riverside Park. Only a small part of the original log structure remains that served Washington during the French and Indian War and later the Whiskey Rebellion. It was then, on October 19, 1794, as president and commander-in-chief that Washington made his final appearance in uniform to review the troops. The 1908 C. E. Gerkins postcard below depicts an 1858 photograph of downtown Cumberland. The back reads, "Dear Flo. Received your letter this morning. Frank and I are to go hunting in the morning, starting out at ½ past 2. All is well and will write Thursday. Love, Porter."

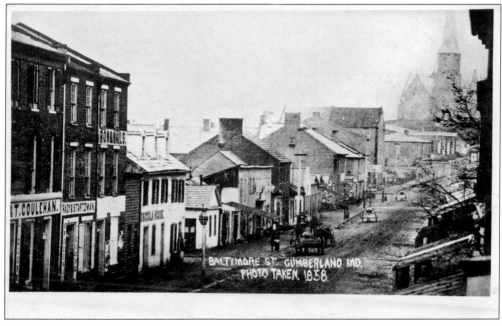

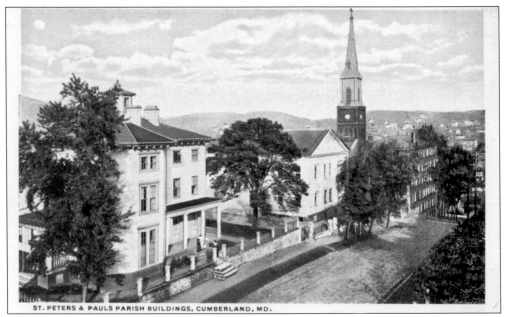

ST. PETERS & PAULS PARISH BUILDINGS, CUMBERLAND, MD.

The SS. Peter and Paul's Catholic Church site was selected in 1848 by Saint John Neumann, a Redemptorist priest and America's first male saint. The cornerstone was laid in 1848 and the church completed in 1849. The parish buildings in this 1919 postcard were replaced in 1931 by SS. Peter and Paul's, later renamed St. John Neumann Elementary School, which closed in 2002. It also housed Ursuline Academy until 1966.

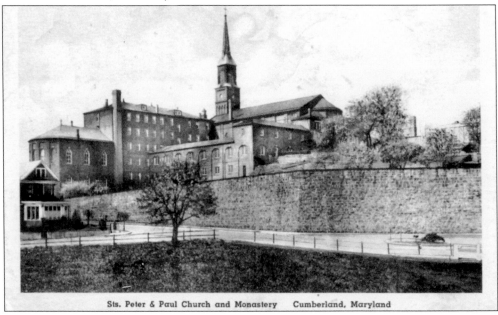

Sts. Peter & Paul Church and Monastery Cumberland, Maryland

In 1902, street excavation necessitated that a massive stone wall be built to protect the Capuchin Friar garden against landslides. The "Great Wall of Cumberland" was constructed at a cost of $10,674.79. At its tallest point, the wall is 31 feet high and 15 feet thick at the base. The area behind the wall is filled with dirt up to seven feet from the top. Work was done by hand or with block and tackle.

SS. Peter and Paul's Catholic Church, the interior depicted here in 1908, was established because of a desire for a church by several Cumberland German Catholic families in 1847. The church itself was constructed between the years 1848–1849. The large, brick monastery, paralleling Fayette Street, was constructed in about 1854 with an adjoining section of the monastery built in 1855–1857.

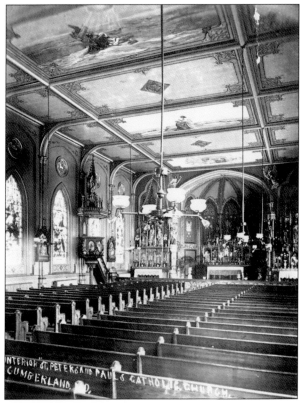

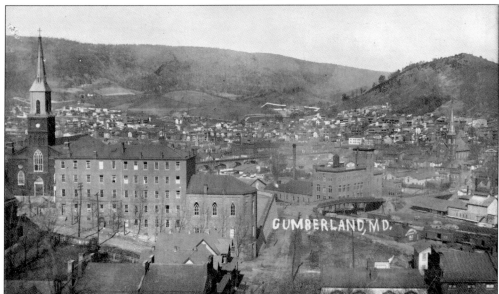

The Redemptorists occupied the church until 1865. The monastery then housed the Carmelites and from 1875 onward the Capuchins, who used the monastery as a training center until 1968. The chapel was completed in 1889 and built onto the eastern end of the monastery at a cost of $8,000. The monastery and chapel were razed in 1997. Depicted on the right is the German Brewing Company plant, established in 1901.

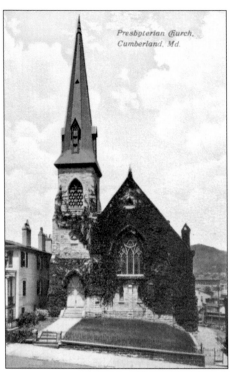

Presbyterian Church,
Cumberland, Md.

The site for First Presbyterian Church was purchased in 1870 for the sum of $5,000. With construction initiated in 1871, the First Presbyterian Church on Washington Street was completed in 1872. The cost of the original building was $47,035, with the spire added in 1892. Early records indicate that a Presbyterian community existed in the Cumberland area as early as 1810. In 1837, steps were taken to incorporate the Presbyterian congregation under the laws of Maryland.

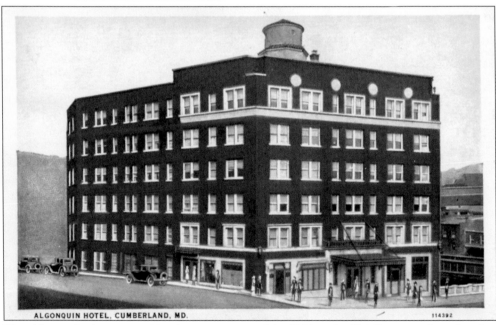

ALGONQUIN HOTEL, CUMBERLAND, MD.

The Algonquin Apartment Hotel was constructed in 1926 and officially opened on October 28 of that year. When opened, the Algonquin boasted 33 hotel apartments, completely equipped, including maid service. About 1936, the hotel was remodeled and the apartments converted to hotel rooms. After 60 years of operation, the Algonquin closed its doors in early July 1986. After renovation, it reopened in 1989 as the Kensington-Algonquin, a senior citizen housing facility.

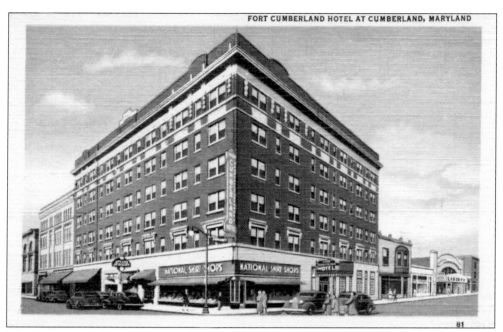

The Fort Cumberland Hotel was constructed in 1916 and held its grand opening in January 1918. It was built at a cost of over $250,000. The hotel exemplifies early-20th-century classically inspired Renaissance Revival architecture with its upper stories ornately decorated with flower drops, floral arrangements, and mermaids. The hotel is now senior citizen housing known as the Cumberland Arms. Note the old Liberty Movie Theater on the far right.

English Lutheran Church, Cumberland, Md.

Established in 1794, St. Paul's English Lutheran Church is the oldest Protestant church in Cumberland and was originally located on the corner of Baltimore and North Centre Streets. Known at various times as the Evangelical Lutheran and Christ's Lutheran Congregation, the St. Paul's church depicted here was dedicated in 1895 and razed in 1957. The current St. Paul's Lutheran Church on the corner of Smallwood and Washington Street was dedicated in 1959.

19

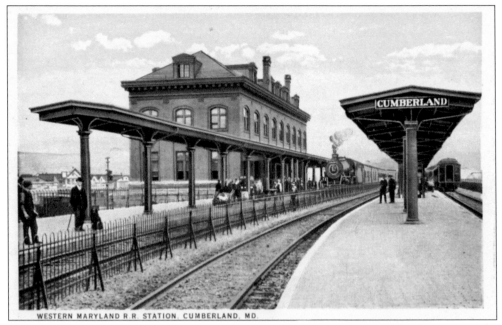

WESTERN MARYLAND R.R. STATION, CUMBERLAND, MD.

The Western Maryland Railroad (WM) had been extended to Cumberland in 1906. The Western Maryland Railway Station was opened in 1913. By the late 1950s, declining revenues began necessitating the elimination of facilities and passenger service. By 1973, the WM had become a subsidiary of the B&O/C&O Railroads, and by 1976, the structure was abandoned. Restoration of the station began in 1983; it now houses the C&O Canal Visitors Center, Tourism Office, and Scenic Railroad.

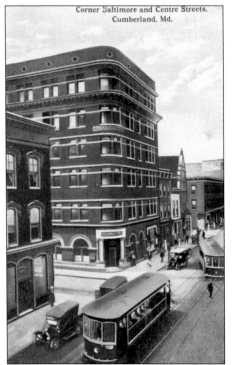

Corner Baltimore and Centre Streets, Cumberland, Md.

Depicted here in 1912, the Third National Bank erected this six-story "skyscraper" at the corner of Baltimore and South Center Streets in about 1906–1907. A bank merger in 1920 resulted in it being named Liberty Trust, then the largest financial institution in Maryland outside of Baltimore. Name changes and relocations followed with the site now serving as an office building. The Cumberland Electric Railway Company had trolley cars running through Cumberland from 1891 to 1932.

The old Second National Bank building, located on the corner of Baltimore and South Liberty Streets, was built in 1890. This magnificent building mixes the Byzantine Revival style with a strong, round-arched Romanesque influence in the treatment of the windows and doorways and a Spanish-type tile-covered roof. Two poised lions and four faces grace the entrance. The site is now home to Susquehanna Bank.

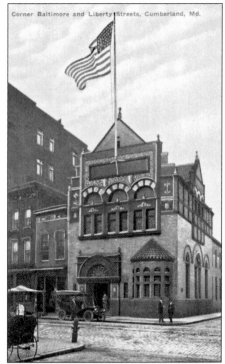

Corner Baltimore and Liberty Streets, Cumberland, Md.

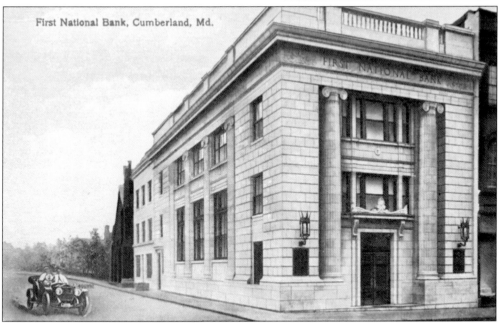

First National Bank, Cumberland, Md.

The neoclassical First National Bank building was constructed at the corner of Baltimore and South George Streets in 1912. The institution was originally chartered in 1811 as the Cumberland Bank of Allegany County and was the first bank in Cumberland. David Shriver Jr., superintendent of construction for the National Road between Cumberland and Wheeling, once served as president. Since 1979, the building has been occupied by First People's Community Federal Credit Union.

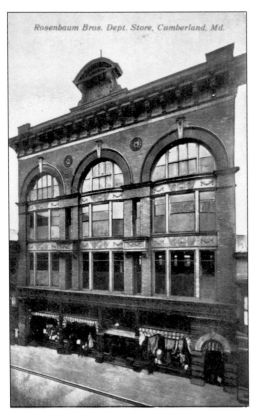

Rosenbaum Bros. Dept. Store, Cumberland, Md.

Rosenbaum Brothers was established in 1878. Their department store was to become one of the largest between Pittsburgh and Baltimore. Rosenbaum's once employed over 200 people. Their second and final was a magnificent 10,000-square-foot, four-story building on Baltimore Street. Bay windows trimmed in stone, human-like sculptures on the keystones, and lions' heads along the roofline comprise a few of the decorative architectural details. The building was constructed in 1897–1898 and opened in 1899. Rosenbaum's closed in 1973. The site is now home to M&T Bank. The postcard below depicts the September 7, 1908, Rosenbaum Brothers' Labor Day Parade float. The sender writes, "John, There will be a dance at Will McElfish's tomorrow night. Be sure and come, Adam."

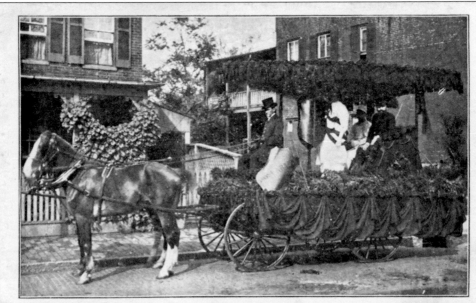

ROSENBAUM BROS' Float Labor Day Parade, Sept. 7, 08, Cumberland, Md.

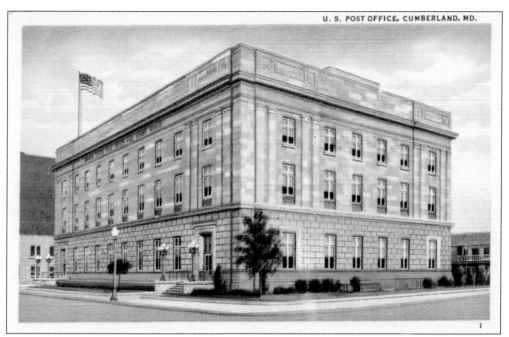

The present District Court Building on Pershing Street was constructed in 1932 and originally served the community as a U.S. Post Office and courthouse. It was designed in the neoclassical Revival style by local architect Robert Holt Hitchins, the same man who designed Frostburg's "new" Beall High School in 1939–1941. During the 1936 flood, water was over 10 feet on South Mechanic Street and the building's first floor was underwater.

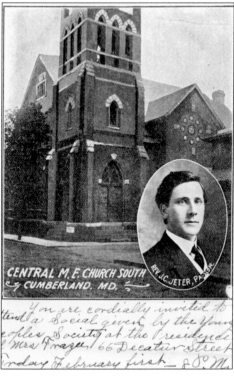

By 1901, there was growing need for a Methodist Episcopal church in central Cumberland. After meeting at various locations, the congregation purchased a house on South George Street for $3,980. The house was soon razed and a cornerstone laid in 1904 for the present Central M.E. (United Methodist) Church. The Gothic-style church featured oak pews, two classrooms, a gallery, and a 45-foot tower that formed the vestibule to both the lecture room and auditorium.

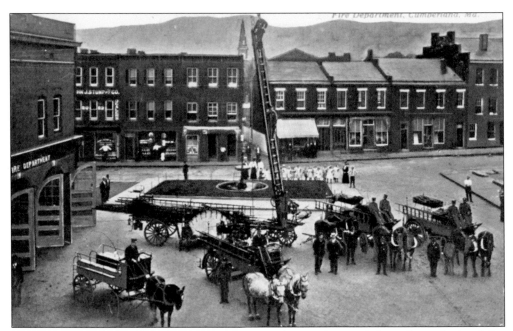

In 1902, several Cumberland organizations met to discuss the possibility of a professional fire department for the city. The paid City of Cumberland Fire Department officially went into operation on March 26, 1906. Central Station No. 1, depicted above in this view at City Hall Plaza, opened with four men. A South Cumberland Station went into service the same day with the West Side Station opening shortly thereafter. By 1907, the Cumberland Fire Department consisted of eight horses, three hose and chemical wagons, one 65-foot aerial truck, one steamer to pump water, and 16 men. The old Central Fire Station building depicted on the right of the view above was razed during the summer of 1978. Below is Decatur Street, looking south from Davidson, as it appeared in the early 1900s.

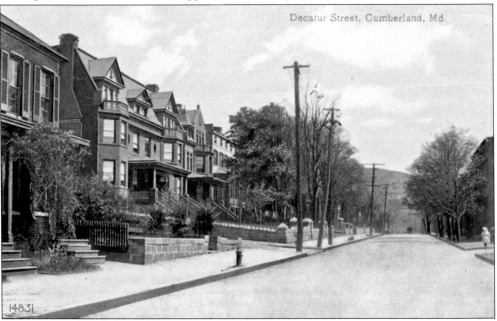

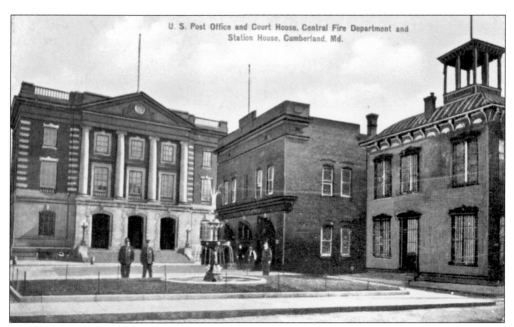

On the far right of the 1910 postmarked card above is the Bell Tower Building. Erected in 1885 at a cost of $2,792.13, it served as a police headquarters and city jail until 1936. It then remained vacant until occupied by the Allegany County League for Crippled Children from 1941 until 1972. In 1973, the building was purchased from the city for $1 and now serves as home to the Allegany County Chamber of Commerce. In 1991, a railroad bell was placed in the small wooden bell tower. The old Central Fire Station (center) was razed in 1978. The C. E. Gerkins postcard on the bottom features the Central Fire Department in the 1907 Labor Day Parade. A poster on the right advertises Buffalo Bill's Wild West Show featuring the "Roughriders of the World," coming to Cumberland in September.

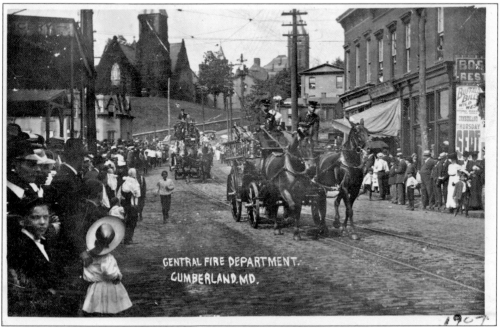

CENTRAL FIRE DEPARTMENT.
CUMBERLAND, MD.

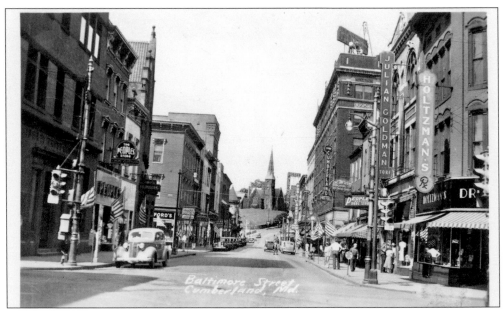

Here is Baltimore Street in the 1940s. From left to right are the Liberty Trust Company, the People's Clothing Store, Ford's Pharmacy (now occupied by the Manhattan Restaurant), Embassy Theatre, and in the middle, Emmanuel Episcopal Church. On the right is the Algonquin Hotel, Public Service Department Store (now CBIZ), Fort Cumberland Hotel, Curtis' Confectionary, People's Drug Store, the Julian Goldman Store, and Holtzman's Drug Store, now home to Mark's Daily Grind.

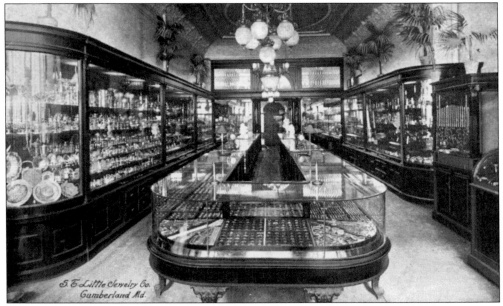

An elegant interior complete with potted palms, painted ceiling, and leaded-glass windows characterize the interior of the S. T. Little Jewelry Store in Cumberland. Established in 1851 by Samuel Trawain Little, the store was located at 113 Baltimore Street in a building constructed in 1904. The store motto was, "Good Goods Come in Little Packages." At the time it closed in 1986, the business had been in operation for 135 years.

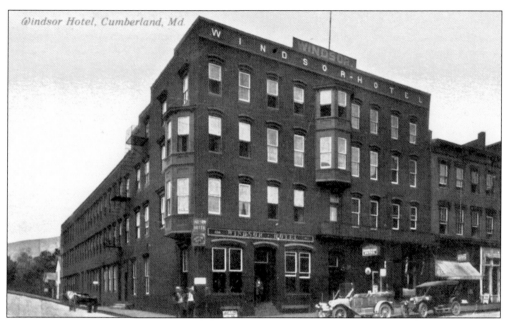

Windsor Hotel, Cumberland, Md.

Constructed in 1842 and originally known as the Washington and then Barnum House, the Windsor Hotel, depicted above, stood on the northwest corner of George and Baltimore Streets in Cumberland. In 1865, a band of Confederates known as McNeill's Rangers rode into the city and captured Union general Benjamin F. Kelley, who was asleep in his hotel bed. Union general George Crook was also captured at the nearby Revere House. McNeill's Rangers were young men from Cumberland and the nearby counties in West Virginia. As the Windsor Hotel, the facility was well known to traveling salesmen. The building was demolished in 1959. A popular restaurant in the 1920s and 1930s, the White Palace Restaurant, shown below, was located in the Windsor Hotel. It advertised itself as "100 percent clean, the best of food at reasonable prices, and always a cold glass of beer."

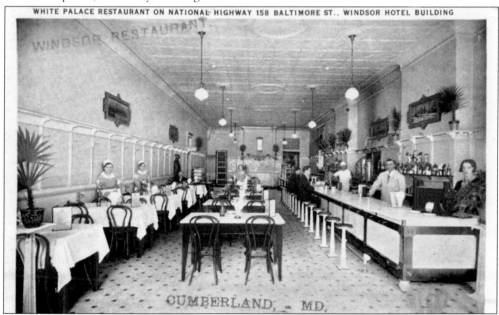

WHITE PALACE RESTAURANT ON NATIONAL HIGHWAY 158 BALTIMORE ST., WINDSOR HOTEL BUILDING

CUMBERLAND, - MD.

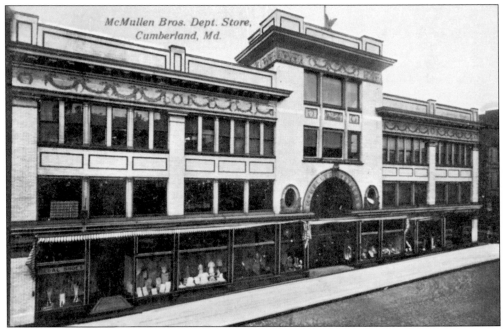

McMullen Bros. Dept. Store, Cumberland, Md.

McMullen Brothers located and enlarged their department store in Cumberland at the corner of Baltimore and North George Streets between the years 1896–1902. The building, shown above in 1912, featured a white enameled brick front with bricks manufactured in Mount Savage. The McMullen Brothers motto was "Tireless Toilers for Trade." An 1897 newspaper advertisement carried the slogan, "Tell it to the Neighbors." In 1933, the *Cumberland Daily News* announced that the G. C. Murphy Company would be occupying a portion of the building's first floor. F. W. Woolworth was also an occupant. McMullen Brothers closed in 1936. Remodeled in 1938 and again in 1958, the structure was recently restored. The C. E. Gerkins postcard below depicts the McMullen Brothers float, which won first prize in the 1908 Labor Day Parade.

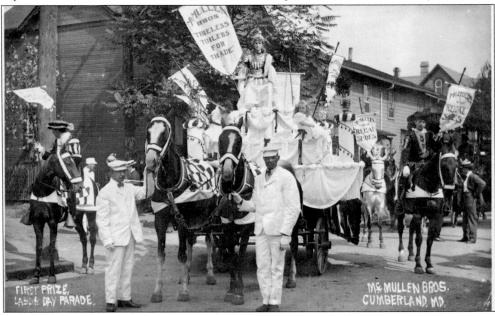

This is the Hospitality Room of the Queen City Brewing Company, located at 208 Market Street. The back of this postcard states, "The Queen City Brewing Company has been in operation since it was founded in 1901 and is famous for its 'original Old German' Premium Lager Beer." Originally known as the German Brewing Company, the company's name was changed to Queen City in 1941 and remained such until the brewery's closure in 1974.

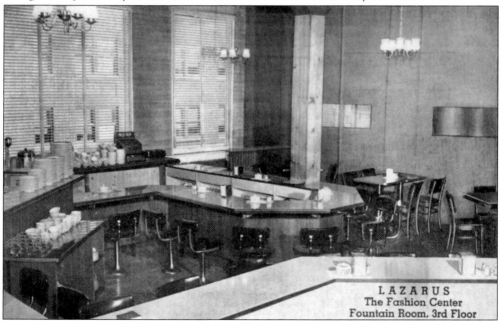

LAZARUS
The Fashion Center
Fountain Room, 3rd Floor

Lazarus was a long-established women's apparel store located on Baltimore Street. The Fountain Room, as depicted in this 1953 postcard view, was a restaurant located on the third floor that served luncheon throughout the year. The back of this postcard identifies Lazarus's third floor as the "Fashion Center of Cumberland" and Cumberland itself as "The Fashion City." Established in 1884, Lazarus eventually closed in 1992.

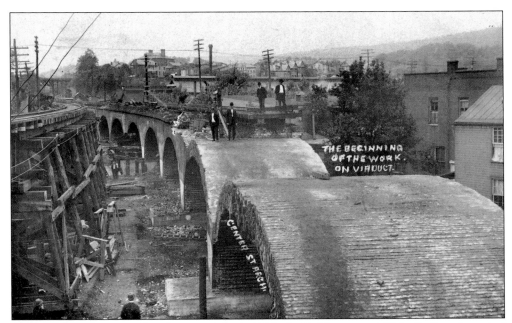

With a Baltimore groundbreaking on July 4, 1828, the Baltimore and Ohio Railroad reached Cumberland November 3, 1842. In 1909, the railroad began reconstruction work on the old brick single-track railroad viaduct built in 1851. When completed, the newly double-tracked concrete viaduct would replace the temporary wooden trestle depicted on the left. The sender of this October 22, 1909, postcard to a "Miss" Vera Amick of Washington Street writes, "Oh! To be fifteen."

This early-1960s view depicts Marple's Modern Motel, located at 231–233 North Centre Street. This is roughly the area between the Center Street Methodist Church and the railroad viaduct where Queen City Drive is now located. The back of this postcard, published by the Triplett Studio of Cumberland, identifies the motel motto as, "Rest in the Best." To contact the motel, one could simply call PA 2-2280.

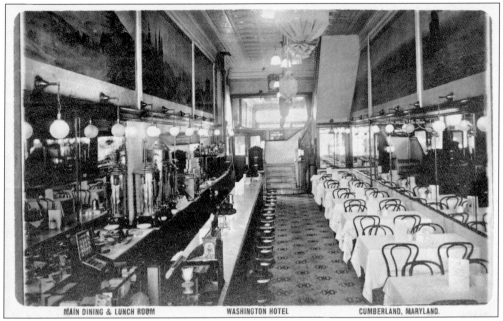

MAIN DINING & LUNCH ROOM WASHINGTON HOTEL CUMBERLAND, MARYLAND.

The Washington Lunchroom and Hotel was constructed on Baltimore Street prior to 1911. This was a theatrical hotel that catered to many famous actors and touring companies that frequented Cumberland's numerous theaters. Depicted above is the hotel's main dining and lunch room. The back reads: "Your Meal Is Now Ready at the Washington. We Never Close. We Have Everything In Season. Our Specialty: Spring Chicken Dinner and the Best Drip Coffee. The Largest and Best Restaurant in Cumberland. Rooms with all conveniences, 50 cents, 75 cents & $1.00." The site is now occupied by the M&M Bakery and Baltimore Street Grill. Below is the Cumberland Dairy Lunch Restaurant located at 45 Baltimore Street. Here you could find homemade pastries and delicious home cooking. As the back of this card states, "When in Cumberland don't fail to visit the Cumberland Dairy Lunch Restaurant, telephone 580."

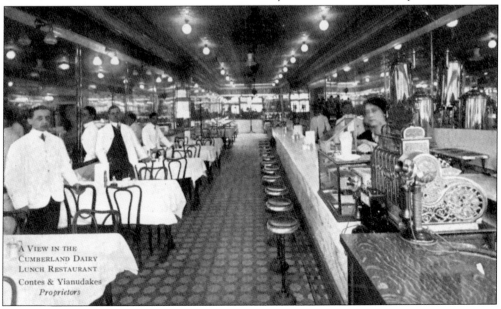

A VIEW IN THE CUMBERLAND DAIRY LUNCH RESTAURANT
Contes & Yianudakes Proprietors

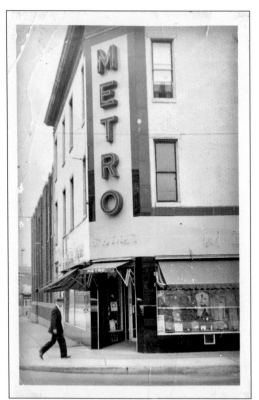

Metro Clothes opened in 1932 and was originally located in the basement of the old Olympia Hotel on the northwest corner of Baltimore and North Mechanic Streets. In 1937, the owner, Joseph Feldstein, the father of this book's author, relocated across the street and extensively remodeled an existing building. After 52 years of operation, Metro Clothes closed in November 1984. The building depicted here was razed during the summer of 1990.

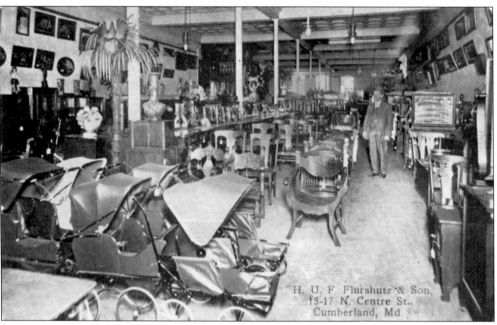

H. U. F. Flurshutz and Son was a major Cumberland-area furniture manufacturer. Much of the firm's handiwork can still be seen in the Cumberland City Hall Council Chamber, as well as in the Masonic Temple. H. U. F. Flurshutz and Son was in existence from 1875 until the late 1950s. Its location on North Centre Street is now occupied by the Book Center.

Construction on the Cumberland City Hall and Academy of Music began in 1874 and was completed with its formal opening in 1876. The massive building had 18-inch-thick walls, was 78 feet high from street to roof crest, and was 140 feet high to the top of the tower. The ground floor was occupied by a Market House, and above were located the beautifully frescoed mayor's office and council chamber.

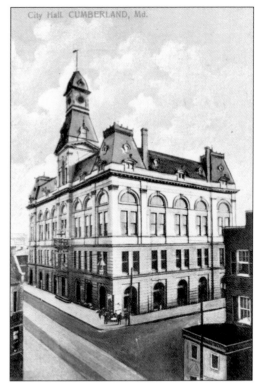

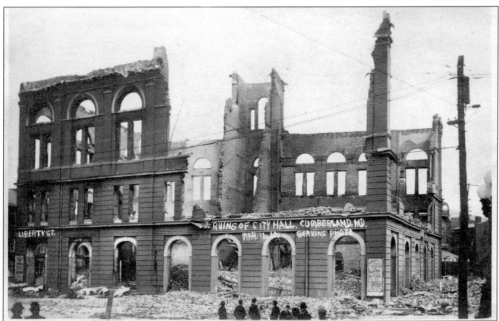

The entire south portion of the city hall above the market was devoted to entertainment and was referred to as the Academy of Music. The academy featured a 30-foot-wide by 30-foot-deep stage, four VIP theater boxes, and a seating capacity of 1,300, but at various times, it was packed to the walls with over 2,000 people. Built at a cost of $127,000, it was destroyed by fire on March 14, 1910.

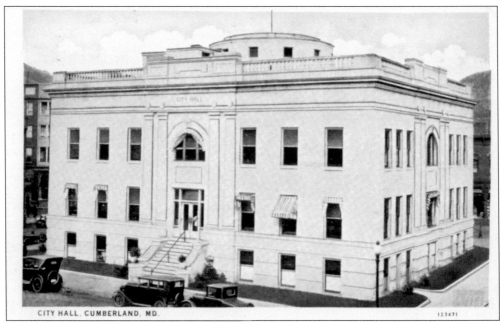

CITY HALL, CUMBERLAND, MD.

123471

Cumberland's city hall was built during 1911–1912 at a cost of $87,000. It stands upon the site of the old city hall/Academy of Music. Plans called for a dome, but at $6,000, it was considered too expensive. The circular foundation for the cancelled dome is still visible on the roof. The interior rotunda features a mural by artist Gertrude Dubrau depicting the city's early history, Fort Cumberland, Gen. Edward Braddock, and George Washington.

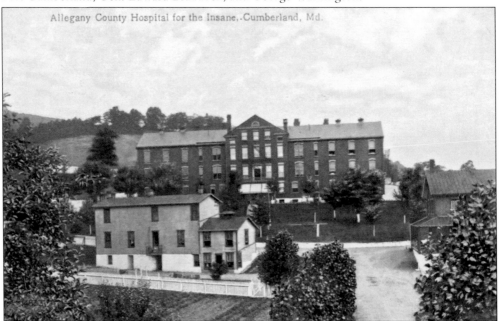

Allegany County Hospital for the Insane, Cumberland, Md.

The Allegany County Hospital for the Insane (the Alms House) on Little Valley Road was enlarged as the county home and later became known as Sylvan Retreat. It was razed in about 1978. The back of this 1910 postcard reads, "I received your letter and cards and am glad to hear from home. Please write every week and I will send you a card when I get ready to leave."

34

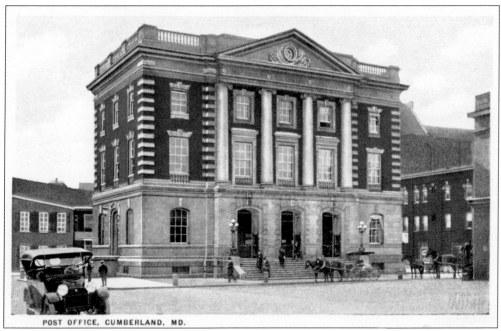

POST OFFICE, CUMBERLAND, MD.

Constructed at a cost of $125,000, the cornerstone for the Frederick Street Post Office and U.S. Courthouse was laid in 1902, with the building dedicated in 1904. Its architectural style mixes Beaux-Arts and Romanesque with elements of Classical Revival. The post office and courthouse relocated to Pershing Street in 1932, and in 1934, the building was bought by the city for use as a police station. It is now the Cumberland Senior Citizens Center.

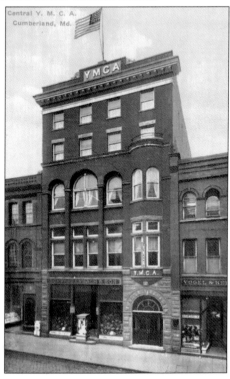

In 1893, a lot was purchased for $12,000 and a cornerstone laid on Baltimore Street for the Young Men's Christian Association building. Formally opened in 1894 and originally three stories high, two additional stories were added in 1910. Game rooms, dormitories, a gymnasium, and running track were featured. The building served as a Y until its 1926 relocation. Although Peskin's Specialty Shop occupied the building from about 1940 to 1992, the letters YMCA remain emblazoned on the roof.

35

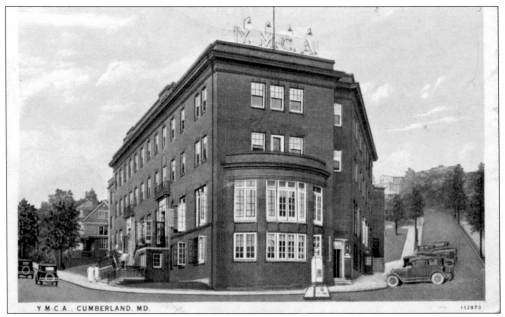

After World War I, the old Y was felt inadequate, and a site at the intersection of Baltimore Street and Baltimore Avenue was purchased. The cornerstone was laid in 1925, with the "new" YMCA opening the following year. It featured a 20-by-60-foot pool. Records indicate YMCA activity in this area as early as 1869, with the first recorded charter being in 1874. A brand-new YMCA opened on Kelly Boulevard in 1997.

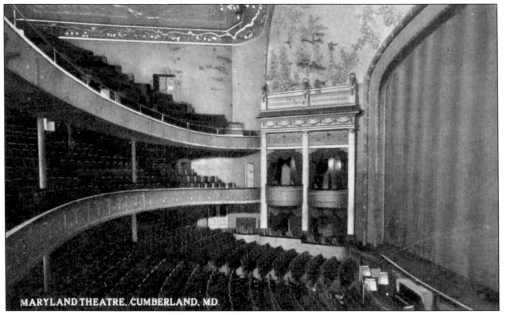

MARYLAND THEATRE, CUMBERLAND, MD.

The Maryland Theatre on North Mechanic Street, depicted here in 1915, opened in 1907 with the state's largest stage. The Great Houdini opened his road show here in 1925. Other performers included Al Jolson and the Marx Brothers, as well as stage presentations such as *Ben-Hur* in 1919, with live horses for the chariot race. The Maryland Theatre showed its last movie in 1963 and was razed in 1964.

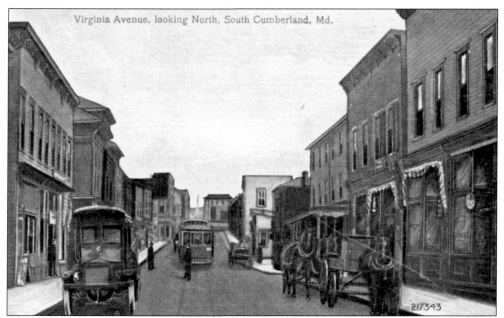

Virginia Avenue, looking North, South Cumberland, Md.

Virginia Avenue was South Cumberland's commercial business district. During the 1920s, Virginia Avenue boasted 114 stores and businesses. These featured a strong and varied mix of restaurants, stores, banks, fraternal and civic organizations, and a theater. Trolley car service to Virginia Avenue began in 1891, and it was among the last lines to cease operations when on May 16, 1932, the last trolley car returned to the Cumberland Electric Railway car barn.

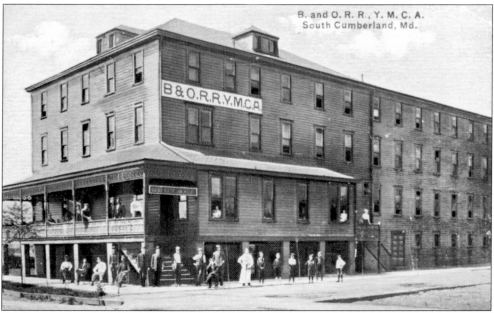

B. and O. R. R., Y. M. C. A.
South Cumberland, Md.

In 1905, the old Eutaw House on Virginia Avenue was purchased by the B&O Railroad, and it henceforth became known as the B&O Railroad YMCA. The bar was turned into a storage area, along with baths and toilet rooms. A large annex, which once hosted prizefights, was turned into an auditorium for concerts and religious services. The old B&O Y, seen here in the early 1900s, was closed in 1967 and the building razed.

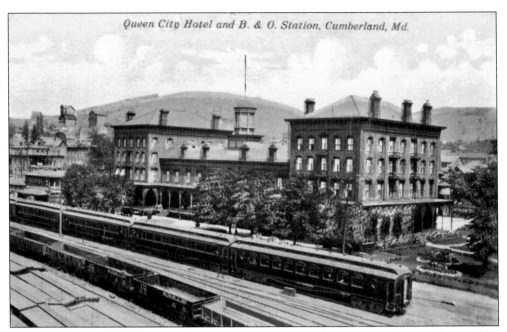

Queen City Hotel and B. & O. Station, Cumberland, Md.

In 1871, the Baltimore and Ohio began construction on the ornate 174-room Queen City Station Hotel. The grand opening was held on November 11, 1872. The Queen City featured a 400-seat dining room on the ground floor, which was also used for socials and ballroom dancing. In the basement were a laundry and game rooms. The hotel also featured a barbershop, billiard room, restaurant, tennis courts, floral wrought-iron verandas, and formal gardens.

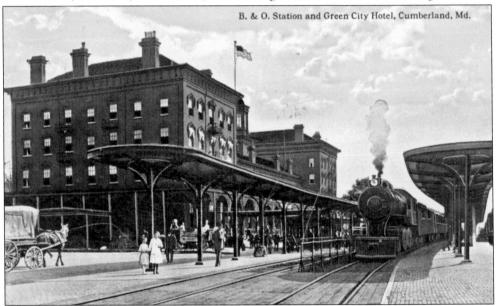

B. & O. Station and Green City Hotel, Cumberland, Md.

This magnificent Station-Hotel was named Queen City in honor of Cumberland's importance as the "Queen City of the Potomac." It had cost over $350,000 to build. The hotel closed December 31, 1964. The B&O commenced demolition on September 24, 1971. The sender of this 1915 postcard writes, "Arrived here late last night. Have a dandy room at this hotel, second floor front. I know you could not stand all this noise of the trains."

38

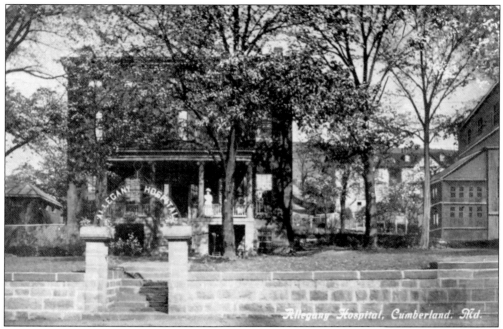

The Allegany Hospital, depicted above in 1910, was founded in March 1905. The 25-bed facility was established on Decatur Street. In June 1911, the Daughters of Charity took over the hospital's administration and within two years tripled the size of the facility. In 1936, the hospital began construction of a five-story annex; as depicted below, in May 1937, Archbishop Michael Curley dedicated the new addition. In 1952, the name was changed from Allegany to Sacred Heart Hospital. Because of a lack of space for expansion, plans were begun about 1957 for a new location. On a 25-acre site on Haystack Mountain, groundbreaking ceremonies took place in 1964 for a new Sacred Heart Hospital. The "new" hospital was officially dedicated on June 11, 1967.

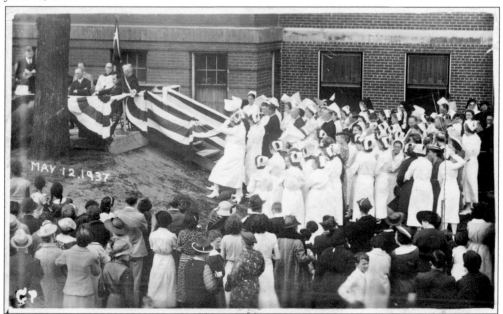

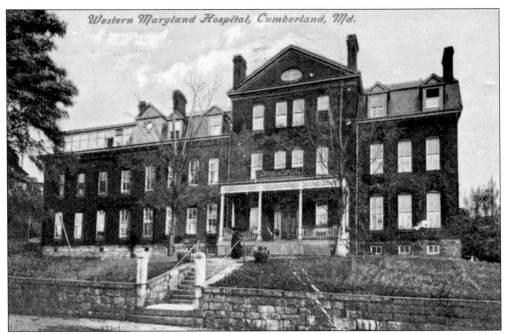

The Western Maryland Home and Infirmary for the Aged was established in 1888. The facilities were initially located in private homes. The need was realized for a larger facility that would provide hospital care for the large number of railroad accident victims. In 1892, a new building was erected on Baltimore Avenue and dedicated as the Western Maryland Hospital. Additions were made in 1900 and 1910. Western Maryland remained a hospital until the facilities were relocated and the name changed to Memorial Hospital, shown below in 1948, dedicated on August 18, 1929. At the time it burned down in 1972, the old Western Maryland Hospital on Baltimore Avenue was known as the Allegany Inn. Memorial and Sacred Heart Hospitals affiliated in 1996 to form the Western Maryland Health System. In 2005, the presence of the Daughters of Charity was withdrawn.

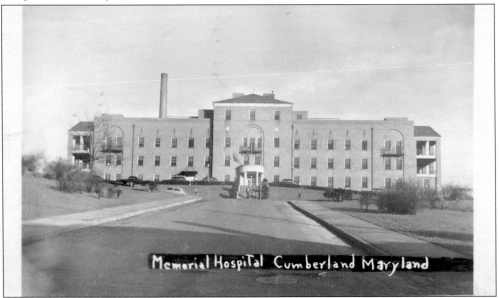

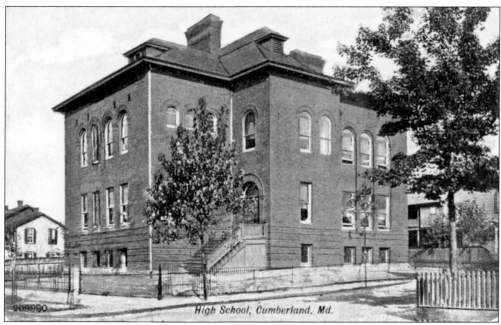

High School, Cumberland, Md.

The Cumberland Street School, above, was built about 1898 and served high school students who were overcrowding the Union Street School in downtown Cumberland. The first floor served elementary students. Up until this time, the high school curriculum covered a period of three years. At Cumberland Street, the curriculum was enhanced so as to require four years for completion. It served in this capacity from 1899 until 1908. Enrollment increased each year, and the need was soon seen for a building exclusively for high school students. In 1908, high school students were relocated to a new Allegany County High School on Greene Street. The Columbia Street School, shown below, was constructed in 1912. At the time of its closing in 1985, Columbia Street was the longest operating school in the city of Cumberland.

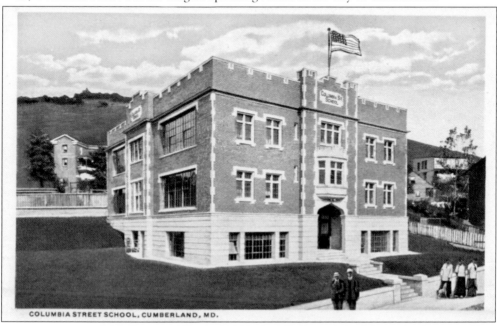

COLUMBIA STREET SCHOOL, CUMBERLAND, MD.

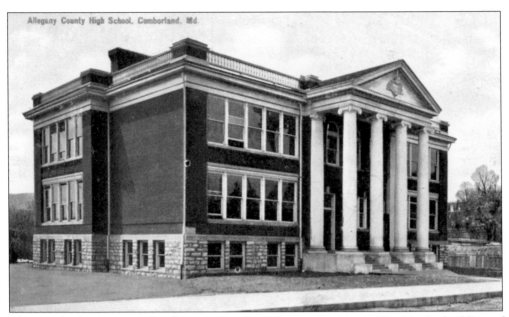

The Cumberland Street School was replaced as a high school in 1908 with the building of Allegany County High School, depicted above, which was located on the corner of Greene and Lee Streets, the current site of the Coca-Cola Plant and Greene Street Gas Station. After the opening of the present Allegany High School at Campobello in 1926, the old school became Greene Street Junior High and served in that capacity until March 11, 1932, when the three-story structure was destroyed by an early morning fire. Since the school was next door to a fire station, this event made *Ripley's Believe It or Not*. At the time of the fire, the school had 1,058 students enrolled. The bird's-eye view below of Cumberland's West Side depicts the 200 block of Fayette Street. Note the Cumberland Street School in the background on the right and the Narrows in the distance.

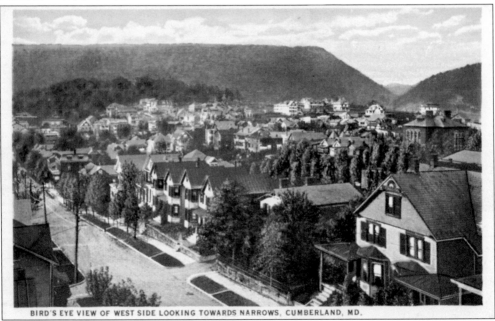

BIRD'S EYE VIEW OF WEST SIDE LOOKING TOWARDS NARROWS, CUMBERLAND, MD.

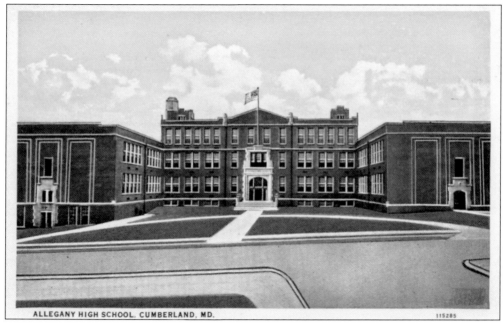

ALLEGANY HIGH SCHOOL. CUMBERLAND, MD. 115285

By 1920, the need was seen for a larger city high school. The present Allegany High School had its cornerstone laid in 1925 and opened for classes in September 1926. Allegany is located on a tract known as Campobello, which is translated to mean, "War Camp." This was the site of a Union encampment during the Civil War under the command of Gen. Lew Wallace. He later wrote *Ben-Hur.*

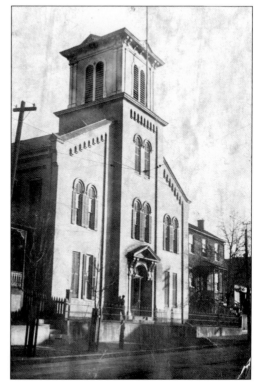

The Maryland Avenue School, depicted here in 1913, was built as an elementary school in 1874. In 1878, the first county high school department was located here. It consisted of one teaching principal. High school applicants had to pass a written examination based upon sixth-grade studies. Seniors studied geometry, natural philosophy, Latin, Greek, and English literature. The high school later relocated to Union Street, with the first graduation of 15 students taking place in 1889.

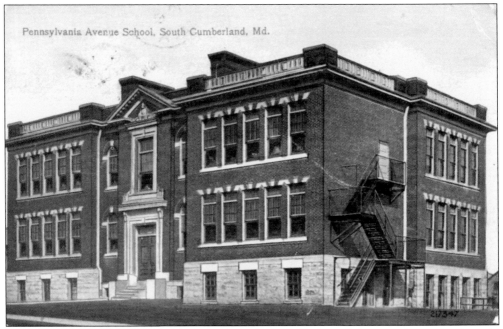

The Penn Avenue School was constructed in 1909. The original school consisted of only eight classrooms and served elementary school children. Additions were soon made, and in 1925, the first two years of high school were started. By 1928, there were 23 faculty members and about 740 students. In 1936, the Pennsylvania Avenue School graduated its largest class of 108 students. It was also in June of that year the high school closed with the fall opening of the recently completed Fort Hill High School. Depicted below is a 1907 view of Pennsylvania Avenue.

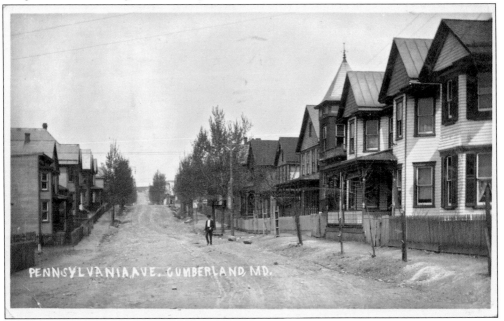

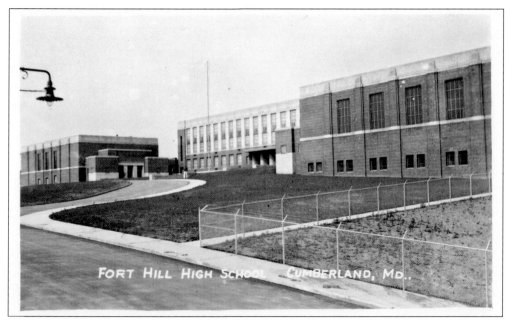

Fort Hill High School opened in 1936. In August 1864, Confederate troops under Gen. John McCausland were marching toward Cumberland. Panic struck and over 200 people volunteered to assist Union general Benjamin Kelley in its defense. Union artillery was stationed in an area today known as Nave's Crossroads. The Cumberland militia was stationed on Kelley's right flank, along what is now Williams Road. Cannon and musket fire opened up on 3,000 Confederates as they came down the Baltimore Pike. The Confederates retreated. This became the Battle of Folck's Mill. When the new South Cumberland high school was built, they named it Fort Hill because it was on that hill the Union army had erected a small fort and the volunteer militia had also built their trenches to defend the city. Depicted below is an early-1900s view of Grand Avenue in South Cumberland.

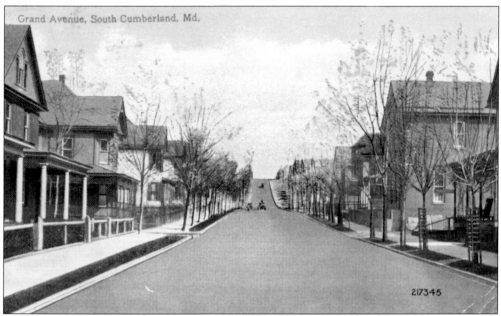

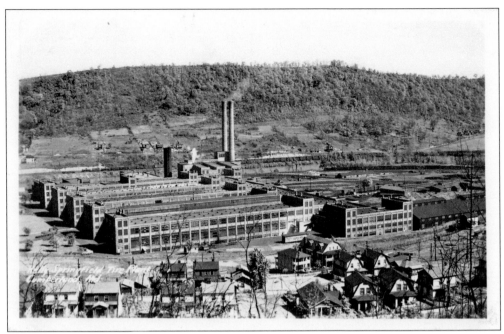

The Kelly-Springfield Tire Company located in Cumberland due in large part to the efforts and vision of local businessmen working together as the Cumberland Development Company, a subcommittee of the Cumberland Chamber of Commerce. With the support of local citizenry, this group pledged $750,000 in 1916, along with a free site, to help locate the Kelly plant in Cumberland. Construction began in 1917, the plant was completed in 1920, and the first tire was produced on April 2, 1921. The plant was leased by the Army Ordnance Department during World War II and produced 50-caliber shells and eight-inch artillery. The factory, as depicted above, closed in 1987. The November 15, 1917, photograph below of Greene Street portrays a westbound streetcar on the opening day of streetcar service to the Dingle.

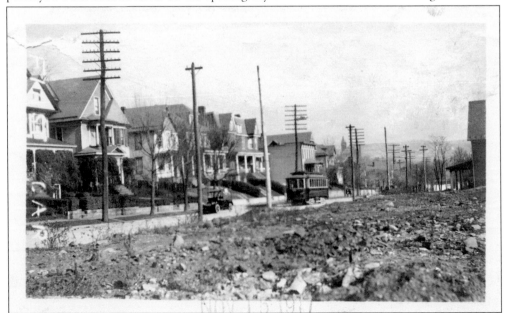

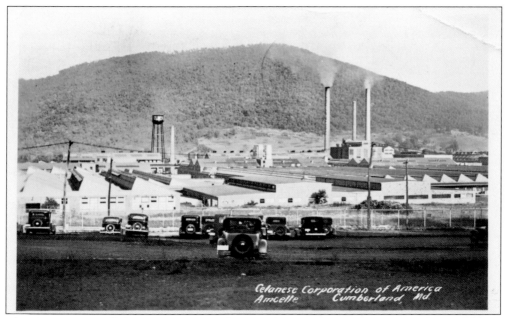

The American Cellulose and Chemical Manufacturing Company (Amcelle) began the production of cellulose acetate yarn here in 1924. In 1940, just one year before America's entry into World War II, Celanese, as the company became known, began the production of a yarn used in the making of parachutes. Celanese, seen here in 1937, ceased production in 1983. The site is now occupied by the Western Correctional Institute, which opened in 1996.

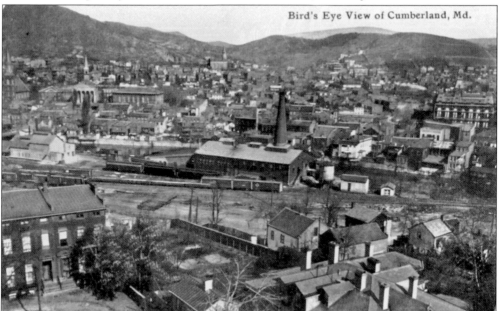

Depicted in the middle is the Potomac Glass Company, which opened for production in 1904. It was located along the banks of Wills Creek and the tracks of the old West Virginia Central, later Western Maryland Railroad. The Potomac Glass Company employed almost 350 people and produced a general line of excellent, quality blown tableware for home and restaurant use. It burned to the ground in 1929 at a cost exceeding $150,000.

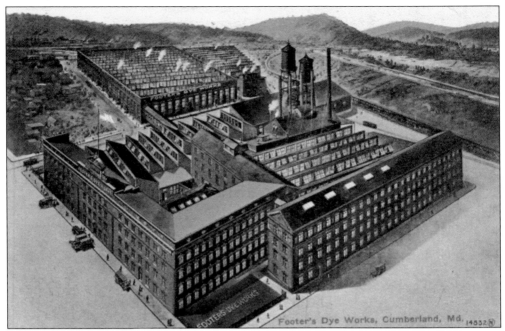

Footer's Dye Works, Cumberland, Md. 14852

In 1904, Thomas Footer undertook a major expansion of his small dyeing and cleaning business and constructed a series of large buildings on South Mechanic and Howard Streets. At its peak, the Footer Dye Works employed over 500 people and was receiving lace curtains from the White House for cleaning. Footer's motto was "Cleanliness is next to Godliness." The dye works closed in 1937 due to general economic conditions and the proliferation of dry-cleaning establishments. Only a few structures remain of the original plant. The large four-story building with the skylights, portrayed above in 1913, is directly adjacent to eastbound Interstate 68. Below is a C. E. Gerkins postcard depicting the Footers Dye Works float that won second prize in the 1908 Labor Day Parade.

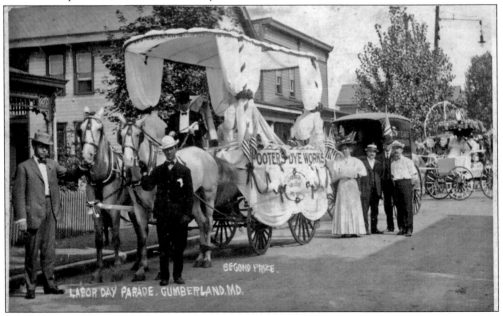

SECOND PRIZE. LABOR DAY PARADE, CUMBERLAND, MD.

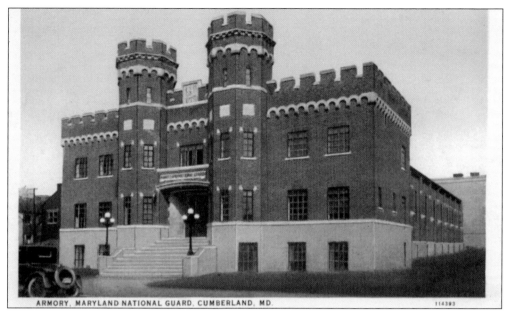

ARMORY, MARYLAND NATIONAL GUARD, CUMBERLAND, MD.

The cornerstone for the Maryland National Guard Armory was laid in 1925. In addition to serving as an armory, the building hosted community, social, and sporting events. These included regularly scheduled boxing matches, as well as roller skating, auto shows, and Miss Maryland Pageants. Such musical stars as Patsy Cline and Porter Wagoner also appeared here. It now serves the community as the Cumberland Armory Convention Centre, Reception and Conference Facility.

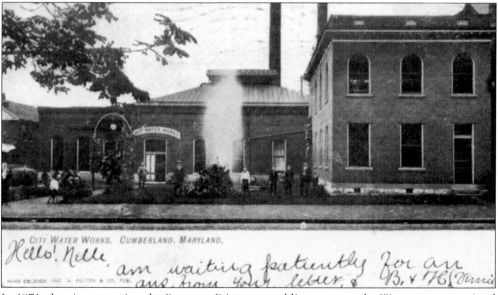

CITY WATER WORKS, CUMBERLAND, MARYLAND.

In 1871, the city was using the Potomac River as a public water supply. Water was transmitted by wooden pipes from a pumping station, seen here in 1906, on Greene Street. Water was pumped directly from the source and not filtered. As industry and population grew, the river became a source of disease, particularly typhoid fever. In 1913, a new water supply, Evitts Creek, was secured with the construction of an impoundment (Lake Gordon), dam, and nine-mile pipeline.

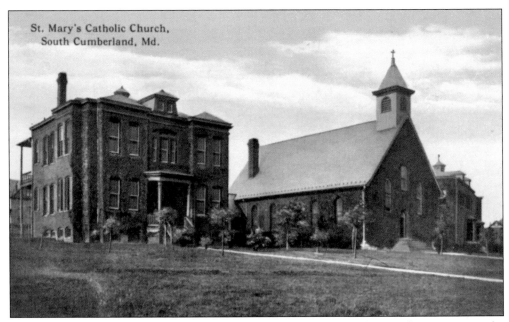

St. Mary's Catholic Church,
South Cumberland, Md.

By the late 19th century, the growth in South Cumberland's Catholic population warranted a new parish. In 1900, a cornerstone was laid for a new church, and in 1901, St. Mary's Catholic Church, the one depicted in this view, was officially dedicated. By the 1920s, the need for a larger facility was foreseen, and in 1928, the cornerstone for the present church was laid. The first mass held in the new church was held on Christmas Day, 1928.

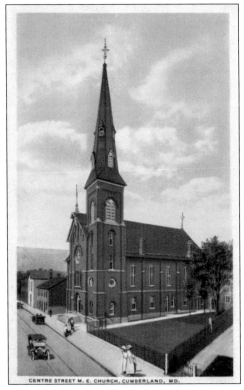

CENTRE STREET M. E. CHURCH, CUMBERLAND, MD.

In the early 1780s, itinerant preachers, such as Francis Asbury, brought Methodism to Western Maryland. By 1782, five years before the establishment of Cumberland, there were 50 Methodists sharing a log cabin with the Lutherans for worship services. In 1816, the present site was purchased. Several early churches existed here until 1871, when a contract was awarded for $23,500 and a cornerstone laid for the present Centre Street Methodist Church.

The German-speaking Evangelical Lutheran Congregation began construction on the Town Clock Church located on Bedford at High Street in 1848. It was dedicated in 1850. Tradition states that the name "Town Clock" stems from an offer by the city to supply a town clock to the church tower completed first by either the German Lutherans or the German Catholics at SS. Peter and Paul's. The Lutheran women held torches and lanterns for their men to work by night in order to complete the steeple and win the competition.

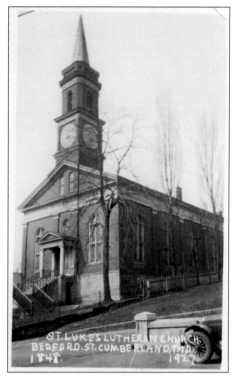

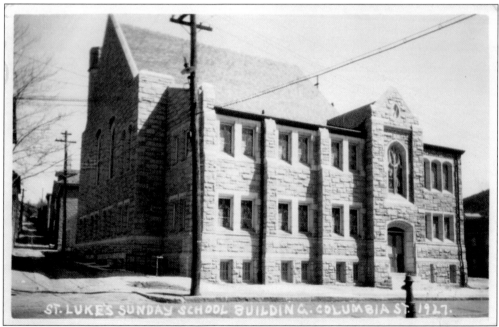

In 1927, the original congregation, the St. Luke congregation, relocated to a new Gothic-style church, depicted here, at the corner of Bedford and Columbia Streets; in 1931, the original 1848 edifice became the First Christian Church. The Columbia Street Church served St. Luke's until the congregation relocated to Frederick Street in 1960. The site then became home to Beth Jacob Synagogue until 1999.

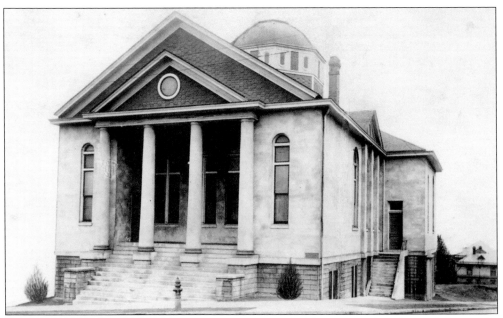

The Second Baptist Church, located at the corner of Oldtown Road and Grand Avenue in South Cumberland, began in 1914 as a mission school. Between the years 1914 and 1924, meetings were held in various locations. A lot on Grand Avenue was purchased in 1916, and construction began on the present church in 1921. The church grew: by the time of the church building's completion in 1925, membership had reached about 150.

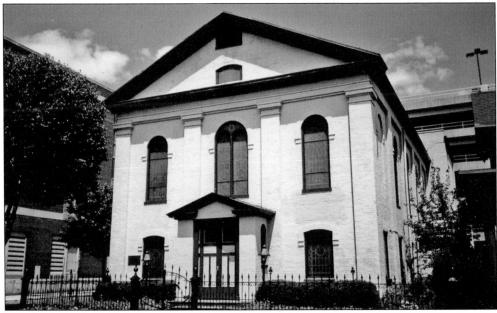

Cumberland's B'er Chayim (Well of Life) Congregation was established in 1853. Steps were taken in 1865 to acquire a site for the temple, and in 1867, the temple was constructed at the corner of South Center and Union Streets at a cost of $ 7,427.02. Weekly dues of 25¢, offerings, and help from other communities paid the construction cost. B'er Chayim is the oldest continuously operating synagogue building in the state of Maryland. (Author photograph.)

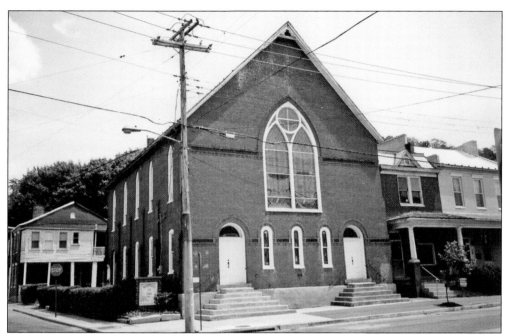

Cumberland's Metropolitan African Methodist Episcopal (A.M.E.) Church was organized in 1837. The first A.M.E. church was erected, largely by freed slaves, in 1848 on Frederick Street Extended, then the edge of town. Over two decades later, a new church was built and later enlarged at a new location on the corner of Frederick and Decatur Streets. The A.M.E. church we know today was constructed in 1892 with the work being undertaken by congregational members and friends. (Author photograph.)

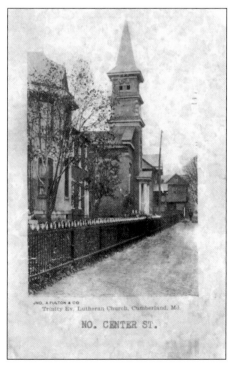

The Trinity Evangelical Lutheran Church was established to serve the German-speaking immigrant population. The congregation dates from 1853, and services were originally conducted at the Canada Hose House on North Mechanic Street. The present church on North Center Street was dedicated on December 24, 1854. Services were originally conducted in German, and a German school was also established. It was during World War I that German was eliminated to show the congregation's loyalty to the United States.

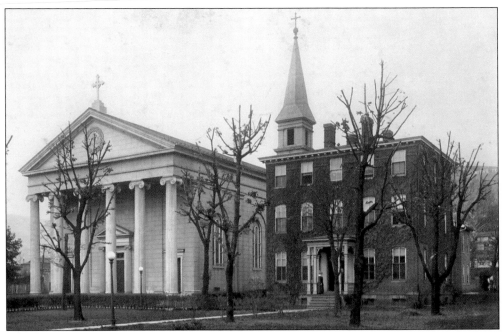

St. Patrick's Catholic Church can trace its history back to 1790 when a parish was established and the first mass celebrated. A log chapel was erected in 1791 and a brick edifice built in 1836. The parish grew, and between the years 1849-1851 the present church, seen above, was constructed. Originally known as St. Mary's, the name was changed to St. Patrick's due to the influx of Irish into the parish who had come west with the Baltimore and Ohio Railroad and the Chesapeake and Ohio Canal. Parishioners from Georges Creek came by train for St. Patrick's 1851 dedication ceremony. Windows and candles lit the church until 1867, when gas lighting was installed with electrification in the early 1900s, as depicted in the below interior view from 1907.

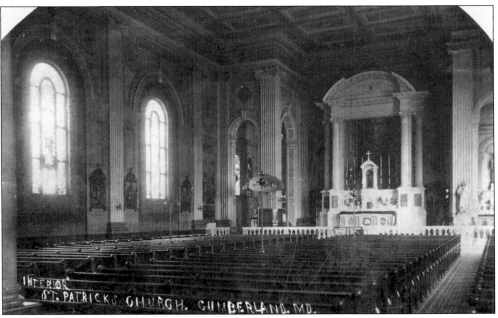

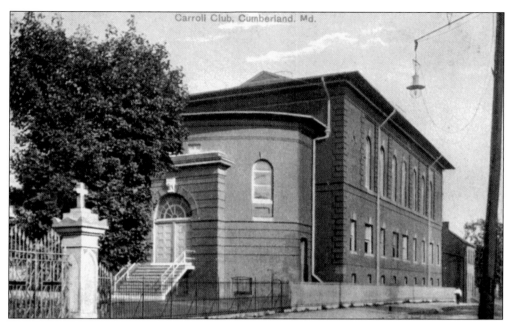

Carroll Hall, shown above in 1909, was constructed in 1903. The building originally served as a social hall and sports center and also housed the Carroll Club. It went on to house the all-boys LaSalle Institute that had been established in 1907. Carroll Hall (which became LaSalle High School in 1938) served in this capacity from 1924 until 1966 and the opening of Bishop Walsh. Carroll Hall was razed in 1987.

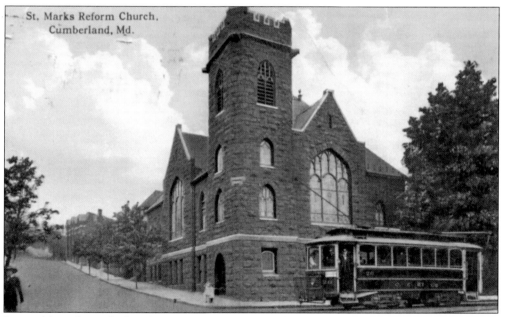

St. Mark's Reformed Church, pictured, was organized in 1891, and in 1892, a lot was purchased at the corner of Harrison and Park Streets. A small chapel originally stood on this site. In 1912, the cornerstone was laid for the present structure. St. Mark's was erected at a cost of $22,000 and dedicated on March 16, 1913. Note the Cumberland Electric Railway Company trolley car.

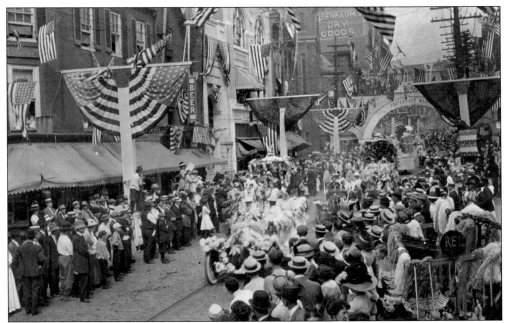

Above is the 1912 Homecoming Parade looking east on Baltimore from Liberty Street. Note the trolley tracks from the Cumberland Electric Railway Company. The first trolley car tracks in Allegany County were laid on Baltimore Street in April 1891. These ran north on Centre Street to Narrows Park in lower LaVale. By May, tracks were laid to Virginia Avenue in South Cumberland. Operations formally opened to the public on July 4, 1891. Trolley car service ended at 1:30 a.m. on May 16, 1932, when the last trolley car returned to the Cumberland Electric Railway car barn. This concluded trolley car service in Cumberland and Allegany County. Below are members from the Electrical Workers Union No. 307, poised at their 1912 float in front of city hall.

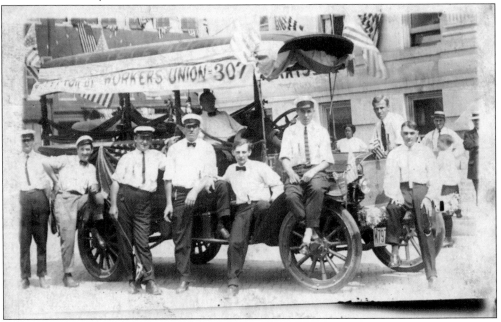

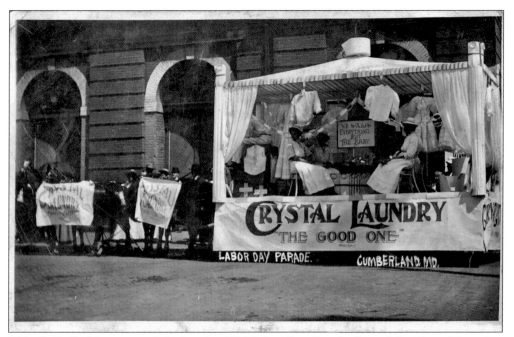

This C. E. Gerkins postcard depicts the 1908 Labor Day Parade float of the Crystal Laundry, which proclaims itself, "The Good One." Note the Crystal Laundry's motto, "We wash everything but the baby."

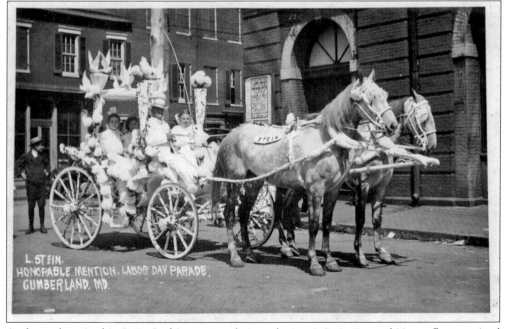

As shown here in this C. E. Gerkins postcard view, the Louis Stein Funeral Home float received an honorable mention in the 1908 Labor Day Parade. The float is in front of the old city hall and Academy of Music, which would burn to the ground in 1910.

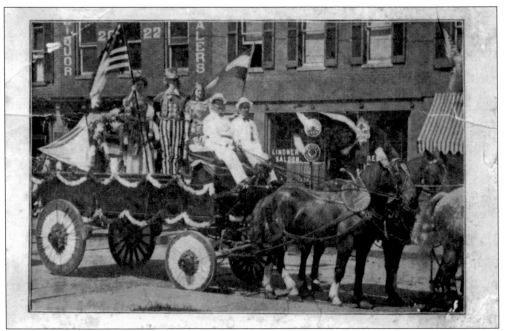

The German Brewing Company's float is depicted in this September 7, 1908, Labor Day postcard. The company was established in 1901. It underwent several name changes over the years. With America's entry into World War I in 1917, the name was changed to the Liberty Brewing Company. Following Prohibition (1920–1933), the original name was reinstated. In 1941, the name was changed to the Queen City Brewing Company. The Queen City Brewing Company closed in 1974.

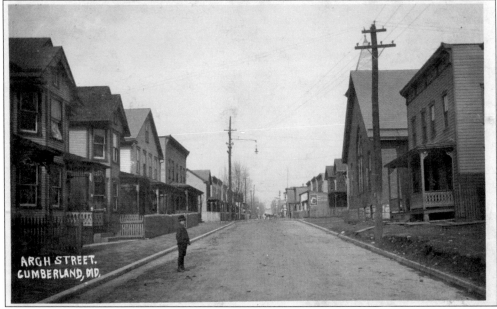

Postmarked 1908, the postcard view above depicts Arch Street in South Cumberland. The sender writes, "Friend Sadie. Here is a picture of your old street. I will write soon. Good-bye for now, Lester."

This photograph by James Edward Grabenstein depicts the corner of Oldtown Road and Massachusetts Avenue in South Cumberland.

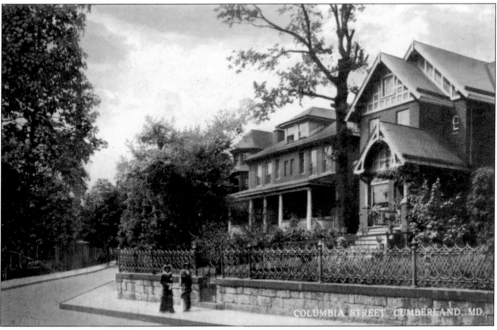

The back of this early-1900s depiction of Columbia Street reads, "Dear Warren, I arrived here at 3 P.M. and have had a wonderful trip so far. The mountains and homes here are beautiful. Love, Bessie."

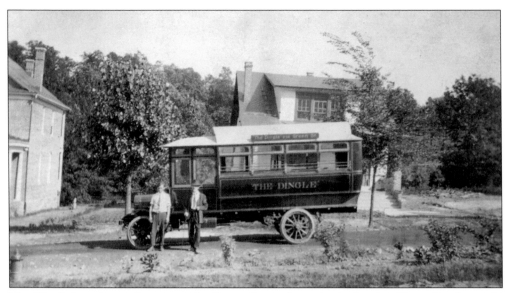

The Dingle bus, shown above, was the first such transit service in the city. Operations began in 1914, and the route ran from city hall to the developing Dingle area. The cost was 5¢ per ride. The Dingle, depicted below in a photograph taken on September 10, 1916, by Joseph Meyers, was a private residential development in Cumberland's West Side. Excerpts from a letter written by the developer in 1926 states, "I named it 'The Dingle' after a beautiful private estate on the outskirts of Liverpool, England. . . . The Dingle lies between two roads [McMullen Highway and Braddock Road], and means a 'Hollow between the Hills' which is very appropriate."

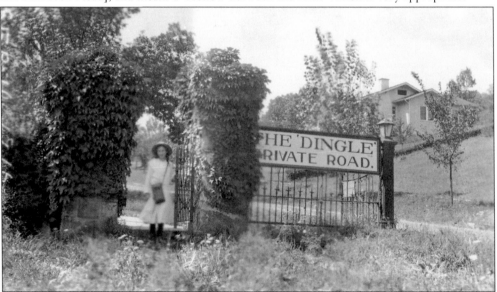

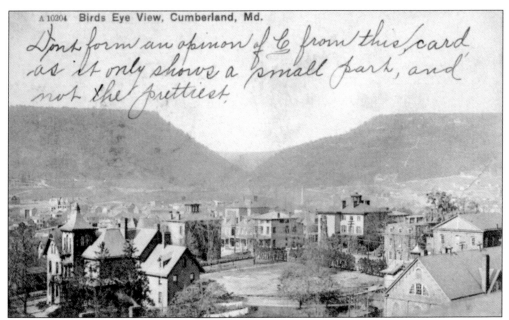

Dont form an opinion of C from this card as it only shows a small park, and not the prettiest,

This 1908 postcard of Cumberland's West Side features the old Roman House, razed in the 1950s, on the left. The corner of Washington and Smallwood Streets is now occupied by St. Paul's Lutheran Church. The sender writes, "Don't form an opinion of C[umberland] from this card as it only shows a small park, and not the prettiest. I have been sick in bed for two weeks and to pass away the time am sending friends postals."

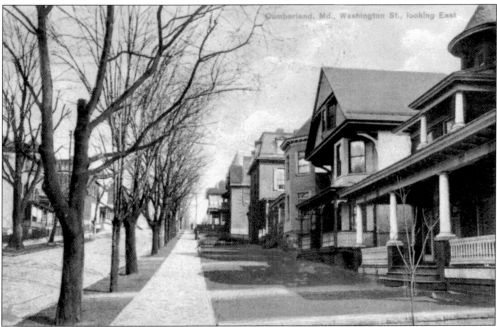

Dated May 12, 1910, this postcard depicts the 200 block of Washington Street, looking east. The sender writes, "Dear Sister, will be at the house the evening of the 23rd if nothing happens to prevent. I know you are having a bout with cleaning and will help you if I can. Wait on me. Mary."

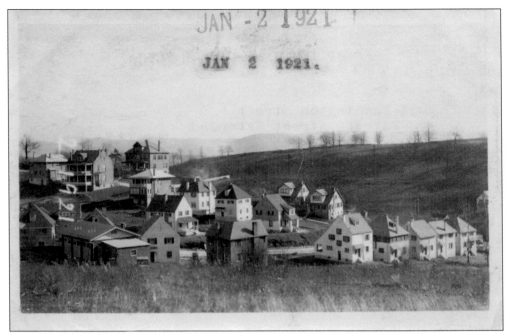

This photograph is of the west side of Washington and Fayette Streets. It was taken on January 2, 1921, by Joseph Meyers. This view looks south, prior to much of the development of this area.

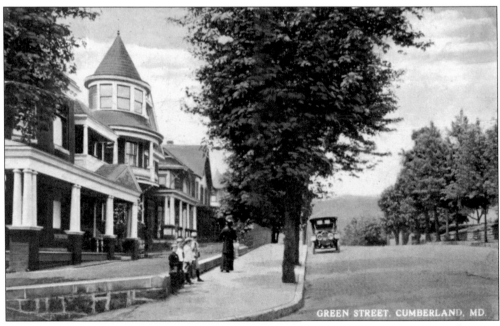

Postmarked October 26, 1920, this view portrays Greene Street looking west from its intersection with Smallwood. The building on the far left is now occupied by the Upchurch Funeral Home.

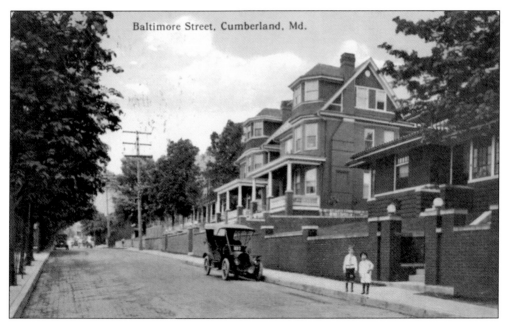

Baltimore Street, Cumberland, Md.

The sender of this early-1900s postcard view writes, "Arrived safe and am having a fine time in this fine town. Will see you soon. Margaret." The scene depicts Baltimore Avenue looking east, just behind the old YMCA building. The Prairie-style house on the right, built in 1912, was once the home of Cumberland mayor Dr. Thomas Koon.

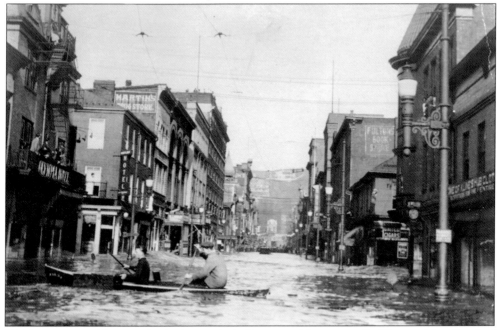

Melting snow and heavy rains had caused the Potomac River to swell. The resulting flood of March 29, 1924, inflicted almost $5 million worth of destruction in the city of Cumberland alone. Half of Cumberland's West Side was flooded to a depth of five feet. Telephone, telegraph, and electric wires were washed away, leaving much of the region in virtual darkness. This scene is looking east on Baltimore Street from the Western Maryland Railroad tracks.

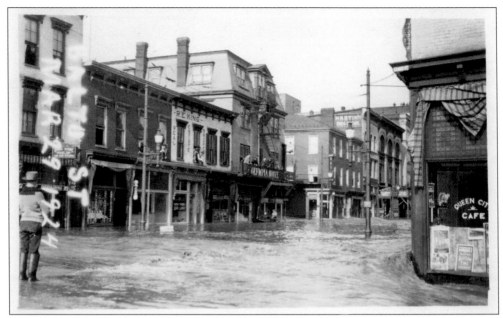

Extraordinary damage occurred along the entire North Branch of the Potomac River, including the towns of Westernport, Luke, and Piedmont. This view, taken from the corner of Baltimore and Canal Streets, depicts from left to right the New York Quick Lunch, Olympia Hotel (razed 1960) at the corner of Baltimore and North Mechanic Streets, and the Queen City Café, where a parklet is now located.

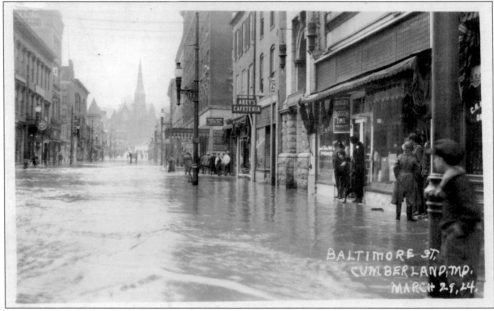

This view of Baltimore is looking west from Centre Street. The flood of March 29, 1924, had been 2.5 feet higher than any previous flood in Cumberland's history. Though not as bad, another flood occurred on May 12 of the same year. It was these floods that resulted in the final closure of an already financially troubled Chesapeake and Ohio Canal as a functioning waterway.

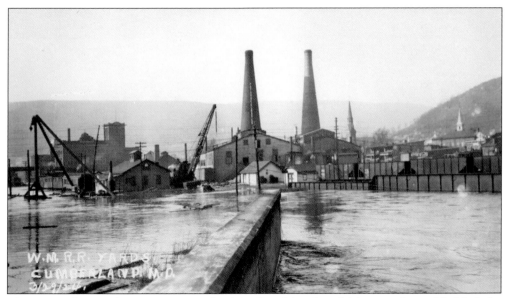

This scene depicts the Western Maryland Railroad Yards, which were located behind the present-day Kensington-Algonquin and along Wills Creek underwater during the flood of March 29, 1924. Visible in the background, from left to right, are the German Brewing Company, Potomac Glass Company, Centre Street Methodist Church Steeple, Carroll Hall, and St. Patrick's Catholic Church.

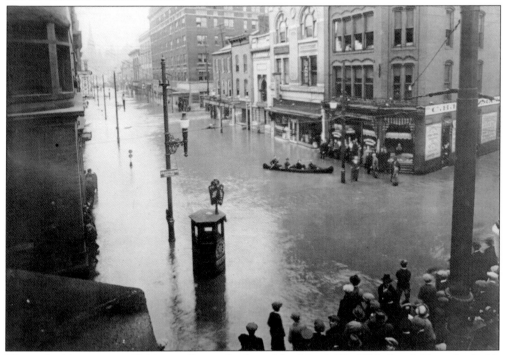

We are looking west on Baltimore Street the day of the March 29, 1924, flood. Note the C. H. Holtzman Drug Store on the corner, now the site of Mark's Daily Grind. A small sign on the left notes the stop for South Cumberland trolley cars. By evening the next day, the water had completely receded and clean-up operations began.

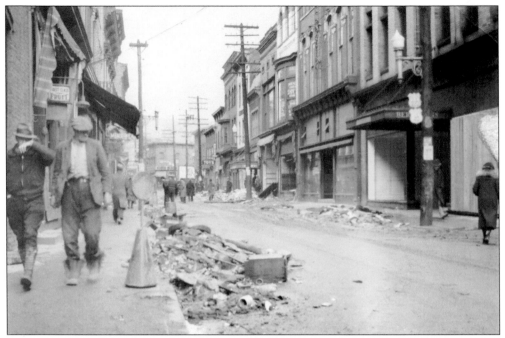

The March 17, 1936, St. Patrick's Day flood began as a downpour. This and the melting snow caused much of Cumberland's central business district to be underwater by mid-afternoon. Many of the first floors of homes and businesses were covered on Mechanic, Baltimore, and Greene Streets, and in some areas, the water rose to a level well over 10 feet. This view of North Centre looks north from Baltimore Street.

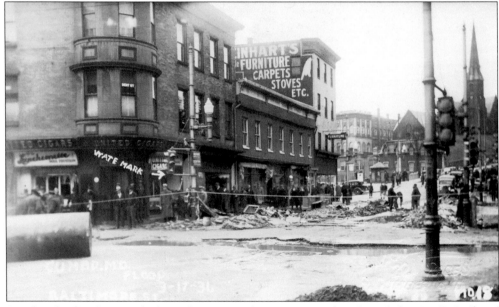

People who lived or worked on the West Side were trapped and used the B&O Railroad viaduct to cross the city. The Red Cross set up an emergency headquarters at the State Armory. Here we see the corner of Baltimore and South Mechanic Streets. Note the white arrow "wate[r] mark."

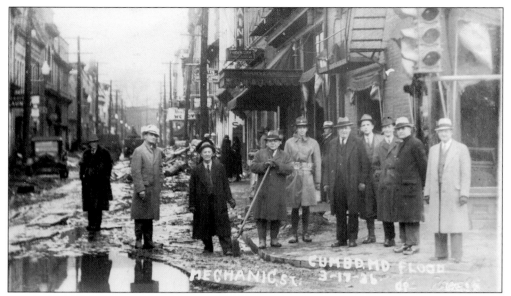

A Mechanic Street resident writes: "We live just up the street a space on Mechanic. I never seen so much water and refuse come down the street like an ocean. I prayed all night long so our house would still be here in the morning." Though Georges Creek also got hit, Cumberland suffered the most damage in the 1936 flood. This scene looks north from the corner of Baltimore and North Mechanic Streets.

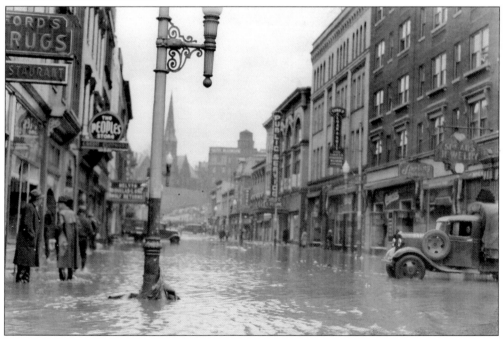

All banks, movie theaters, and businesses were closed, and the National Guard was called out to keep order. Trains, buses, and cars were stranded. Communications were cut off, and the city was isolated for the duration of the high water. Hundreds spent the night in the State Armory cared for by the Red Cross, who estimated the number of families washed out of their homes at 1,200, close to 6,000 people.

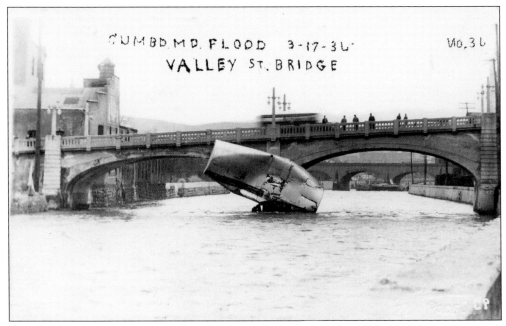

The sender of this card writes: "We lost everything downstairs. This is a big gasoline tank which was right across Mechanic Street. If it ever would have bursted or caught fire, oh how terrible for all. Hope LeRoy, you, and Margaret and boys are all well and happy. Marge got her dress. Will write soon, Florence." Citizens were warned to stay away from the bridge. As can be seen, folks walked out to observe any possible explosion.

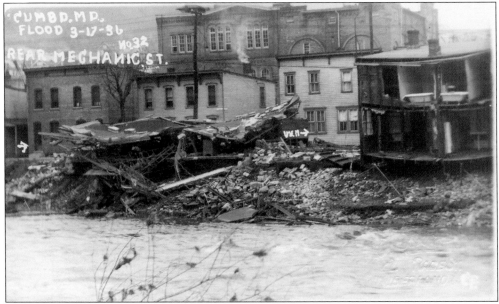

The mayor and city council went so far as to publish a notice that the selling of intoxicating liquors in the city would be illegal until the flood emergency passed. This is the rear of Mechanic Street looking north from Wills Creek during the March 17, 1936, flood. Note the bathtubs exposed on the second floor of the homes on the far right and the Old Export Brewery Company building in the distance.

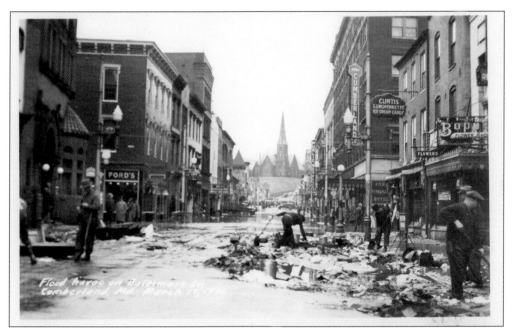

Movie theaters, including the Strand, Embassy, Liberty, and Garden, were closed. Civilian Conservation Corps workers were rushed in, and the city hired scores of workers and contractors. The damaged areas were sealed off, and reconstruction work progressed rapidly. Plate glass poured into town, and over 300 boarded-up windows were replaced. The National Guard was recalled, as were the state police, and the Great Flood of 1936 became history.

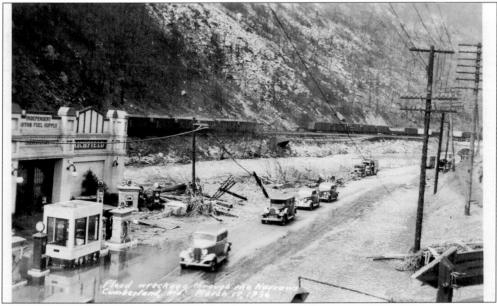

This scene depicts some of the flood wreckage in the Narrows. Note the downed telephone poles and railroad tracks falling into Wills Creek. That is the old Richfield Service Station, bulk oil plant, and tire recapping center on the left, which was built in 1919. It was located roughly where Route 40 crosses Wills Creek in the Narrows. It was razed in the 1950s during the construction of the Flood Control Project.

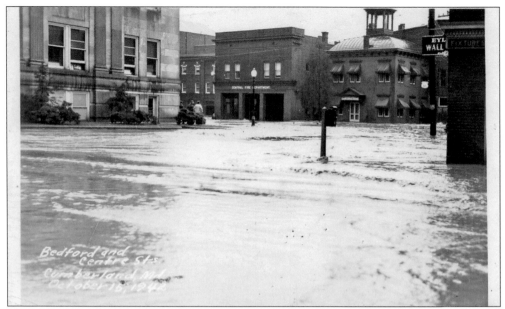

In the flood of October 15, 1942, downtown Cumberland was flooded up to five feet, with water rising all the way to City Hall Plaza. Over 300 people required Red Cross assistance in the form of shelter and canteen service, and over 600 telephones were out of service due to cable and line damage. All business was suspended, and the Maryland State Guard was called in to restore order.

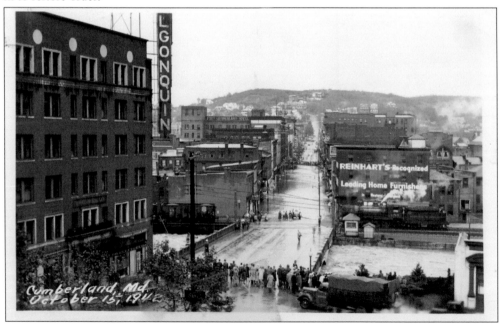

The cellars of many homes along Wills Creek, which was out of its banks for 10 hours, were flooded, as was the basement of city hall. The local chamber of commerce estimated property damage exceeding $50,000. Note the spectators viewing the high flow of Wills Creek beneath the Baltimore Street Bridge. By 1949, work was underway on the Flood Control Project. This was completed in 1959 at a cost of $18.5 million.

Two

LaVale

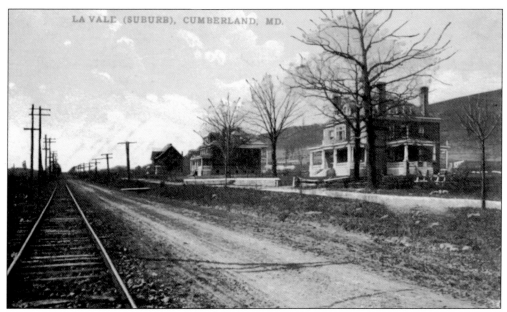

In 1909, a realtor named David P. Miller purchased a half-mile strip along the National Road for use as a real estate development. He named the site LaVale after his Pennsylvania homestead. Although the name originally applied only to this tract, popular usage soon applied the name to the entire area. In 1947, the LaVale Sanitary Commission was established by the Maryland State Legislature, and for the first time, the name LaVale had an official or legal meaning. In that same year, LaVale's boundaries were fixed to parallel Election District 29, and the Long Post Office was officially renamed LaVale to serve the dozen or so neighborhoods comprising the "new" community. The tracks of the Cumberland and Westernport Electric Railway Company (1901–1927) paralleled the National Road through LaVale in the early 1900s. The tracks were removed and Route 40 widened in 1929. The three homes in this early-1900s view of the National Road looking west through LaVale remain today.

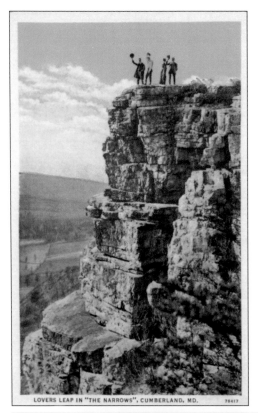

LOVERS LEAP IN "THE NARROWS", CUMBERLAND, MD. 78417

The Narrows is a 1,000-foot-high natural landmark that cuts through Wills and Haystack Mountains. The pass facilitated commerce, travel, and migration between Cumberland and the West. Early roads bypassed the Narrows and followed the Delaware Indian Nemacolin's path, a trail laid out by 1753 for the Ohio Company over the steep mountain passes to the south. This later became Braddock's Road, used in 1755 by Gen. Edward Braddock on his way to the disastrous defeat at Fort Duquesne. It was a Braddock lieutenant who found the Narrows, and a portion of Braddock's army used it. Originally the National Road also followed the mountain passes to the south. After 1832, the federal government rerouted the highway through the Narrows. The scene below, postmarked 1911, depicts Narrows Park in lower LaVale. It featured a roller coaster, swings, a small train, and picnic area and was accessible by trolley car.

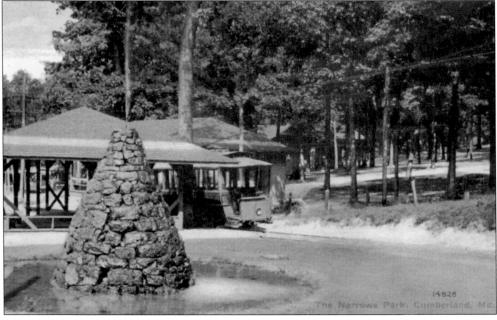

The Narrows Park, Cumberland, Md.

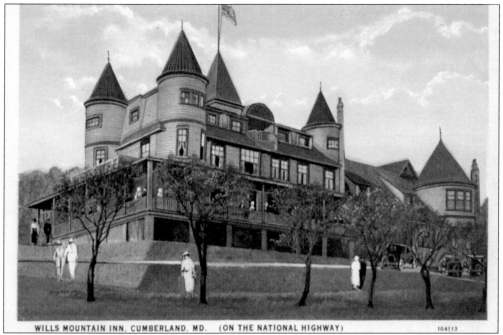

WILLS MOUNTAIN INN, CUMBERLAND, MD. (ON THE NATIONAL HIGHWAY) 104113

The Wills Mountain Inn opened in 1899 and initially served as the Elks Club House but was soon leased to the Algonquin Club as an informal country club. It featured 46 bedrooms with private bath and shower and a grand ballroom. The inn was later converted to a sanatorium where patients paid $25 to $40 per week. The Wills Mountain Inn, which stood atop the Narrows, was destroyed by fire in 1930.

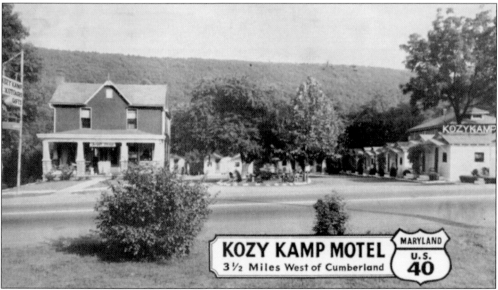

KOZY KAMP MOTEL
3½ Miles West of Cumberland
MARYLAND U.S. 40

This postcard sender writes, "It's vacation time! Spent my first night here, moving eastward. More later." The Kozy Kamp Motel was located on the south side of U.S. Route 40, just east of its intersection with Vocke Road. It featured private baths, automatic heat, clean and cozy cottages, with a homey atmosphere and unexcelled service. Located "In the heart of beautiful scenic Maryland, you will always remember your pleasant stay at the Kozy Kamp Motel."

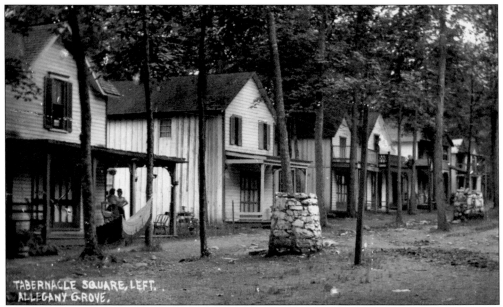

The Allegany Grove, depicted in 1907, was located just west of present-day Vocke Road and down Campground Road. It was a revival meeting site and was served by two nearby local railroads, as well as trolley cars of the Cumberland and Westernport Electric Railway Company. The Grove was Allegany County's foremost summer religious and Chautauqua center. It combined Christian fellowship, camp meetings, and summer recreation for the family. The site featured a tabernacle, 75 summer cottages, a smaller pavilion, and a hotel. Its popularity attracted such well-known persons as John Philip Sousa, Jim Thorpe, Billy Sunday, William Jennings Bryan, Adm. Robert Peary, and Helen Keller. In 1914, a fire destroyed the tabernacle and 65 cottages. In 1918, the hotel was also destroyed by fire and Allegany Grove became a memory.

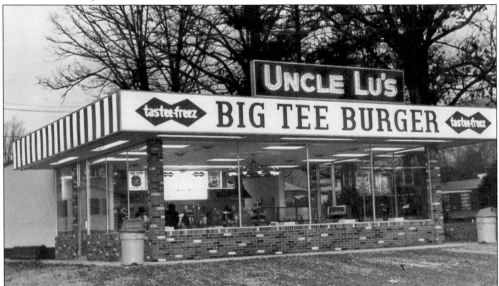

Here is Uncle Lu's Tastee-Freez, which opened in 1957 at the corner of Vocke Road and Route 40.

74

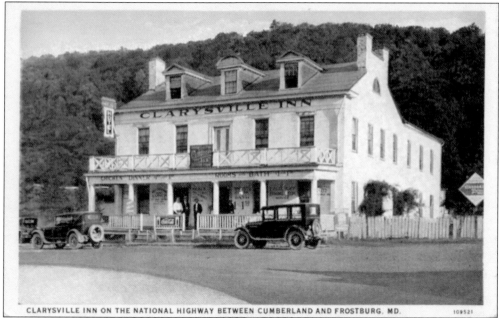

CLARYSVILLE INN ON THE NATIONAL HIGHWAY BETWEEN CUMBERLAND AND FROSTBURG, MD. 109521

In 1807, Gerard Clary purchased 335 acres on a tract known as Hope in Prospect. Shortly afterward, he constructed the Clarysville Inn. Located on the National Road, the main route of travel between Baltimore and Wheeling, the inn prospered for many years as a tavern, stage house, and wagon stand. During the Civil War, the inn served as a convalescent hospital for union forces. In the early morning hours of March 10, 1999, the Clarysville Inn was gutted by a terrible fire.

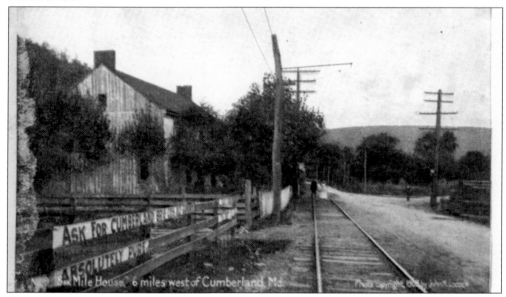

The Six Mile House had the liveliest reputation of all. It was always well stocked with spirits, even during Prohibition. The fence sign reads, "Ask for the Cumberland Brewing Company's Old Export Beer—Absolutely Pure." The Six Mile House was served by trolley car and stood on the north side of the National Road at its intersection with Winchester Road. (E. K. Weller photograph.)

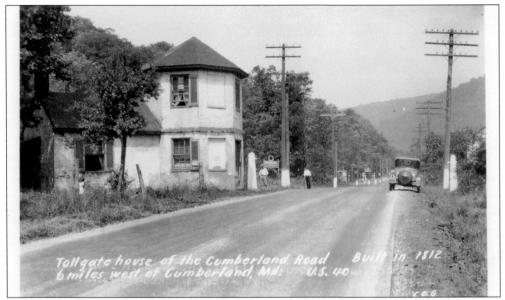

By 1835, Maryland accepted ownership of her portion of the National Road from the federal government. The two-story, seven-sided Toll Gate House was completed in 1836 in order to collect tolls and maintain the road. In its first year of operation, the tollhouse collected $9,745.90 from 20,000 travelers. Maryland collected tolls until 1878; then with the road under county ownership, tolls were collected until about 1900. (C. E. Gerkins photograph.)

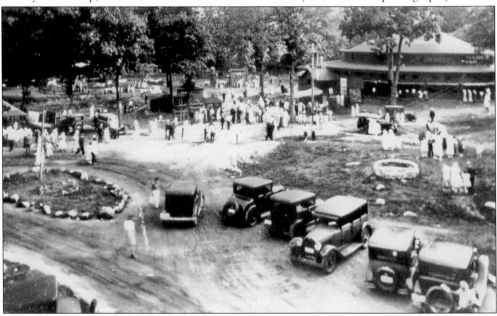

People's Park, later known as Crystal Park, was roughly located just east of the present-day LaVale McDonald's. During the 1920s, 1930s, and 1940s, it attracted hundreds of people daily and featured bingo booths, picnic pavilions, a restaurant, miniature railroad, zoo, 60-foot-high chair-plane, a huge merry-go-round, and a ballroom that hosted the country's most famous bands. The site was later occupied by the Crystal Drive-in. The building on the right later became known as Albert's Supermarket.

In 1949, A. Henry "Henny" and Edith Gehauf opened a small custard stand at the "point" of Winchester Road, the old Braddock Road, and U.S. 40. It was the area's first drive-in and featured shakes, hot dogs, fries, and car-hops. Later known as the Gay Point Restaurant, a 10-unit motel was constructed in 1954. After 57 years of successful growth, it is today the Best Western Braddock Motor Inn, Gehauf's Restaurant, and Henny's Bar and Grill.

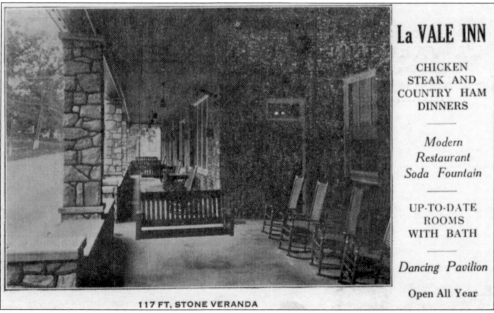

The back of this postcard from the late 1920s reads, "Meet me at the LaVale Inn, three miles west of Cumberland on the National Highway, Telephone 914." The inn stood on a site now occupied by Fratelli's Restaurant. The LaVale Inn featured a 117-foot stone veranda and advertised chicken, steak, and country ham dinners, a modern restaurant and soda fountain, up-to-date rooms with bath, a dancing pavilion, and banquet facilities.

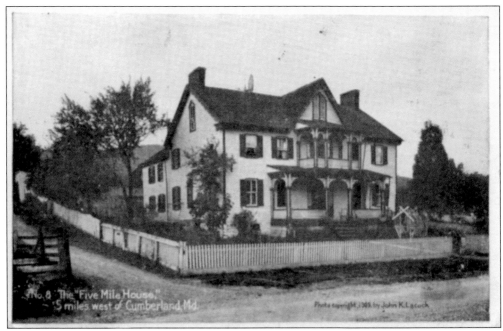

The Five Mile House still stands along the north side of the historic National Road in LaVale. By 1850, coaches from eight different stage lines traveled the National Road from Cumberland to Wheeling. Wagon stands, inns, stagecoach stops, and mile-houses appeared almost every mile to supply fresh horses, food, or lodging. (E. K. Weller photograph.)

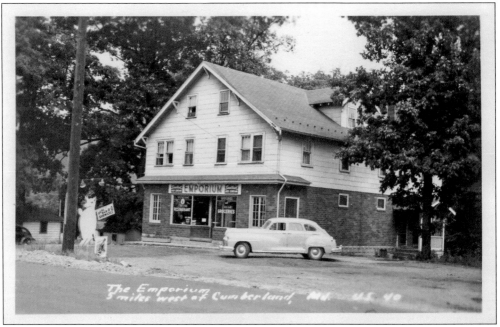

The Emporium stood five miles west of Cumberland on the south side of U.S. Route 40. The building exists today and is occupied by various businesses. The Emporium sold groceries and also housed a restaurant. Seven-up, Sealtest Ice Cream, and "Real Bar-B-Q" sandwiches advertised by the cut-out pig in front were all available here.

Three

FROSTBURG

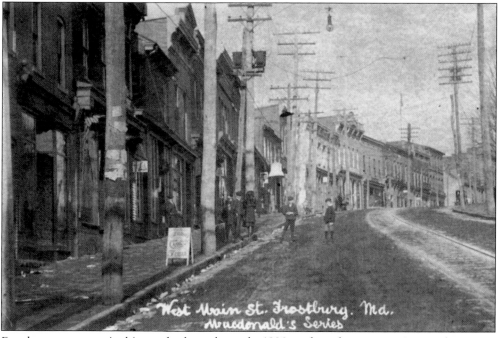

Frostburg can trace its history back to the early 1800s, when the community was known as Mount Pleasant and consisted of only three homes. By the time the National Road opened through in 1812, an early settler named Josiah Frost had laid off the town along its route and was offering building lots for sale. As the town grew, it became known as Frost Town after the 1812 founders, Meshach (Josiah's son) and Catherine Frost, who lived in a home built upon Lot 1. Stagecoach service through town via the National Road began in 1818, and after the first post office was established in 1820, with Meshach as first postmaster, the current name of Frostburg came into being. This 1909 postcard view of West Main Street clearly depicts the tracks of the Cumberland and Westernport Electric Railway. The first trolley car arrived in Frostburg in April 1902. By 1905, companies in Frostburg, Cumberland, and Westernport had merged operations under the Cumberland and Westernport Electric Railway Company. This Main Street view of Frostburg, looking west, is from a card postmarked 1909.

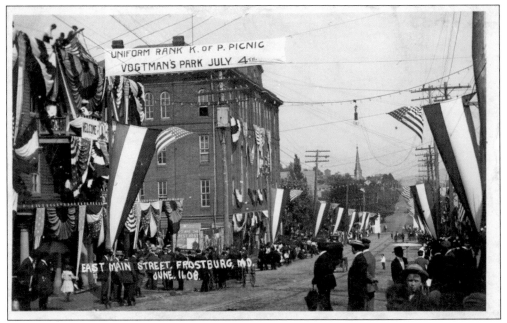

Above is the Fireman's Parade of June 11, 1908. The large building in the middle is Frostburg's Centennial Hall, which was built in 1876 at the corner of Depot and Main Streets. Erected by the Independent Order of Odd Fellows, it had a curved stage with 12 footlights and a theater seating capacity of about 700 persons. The best theatrical actors in the country appeared here. Motion pictures were shown in later years. The building contained a magnificent banquet hall and dance floor on the fourth floor. It was later known as the Ravenscroft Opera House after John Ravenscroft, who purchased the building and owned it until 1902. The Frostburg Opera House, as it was also referred to, was destroyed by fire in 1936.

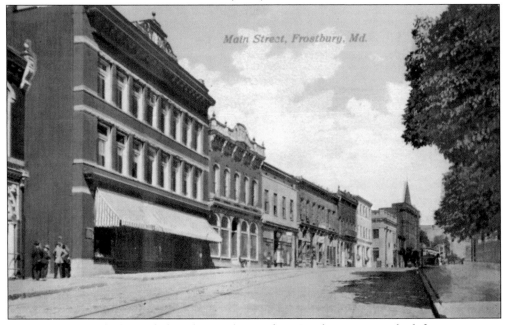

The 1915-postmarked view below depicts the Hitchins Brothers store on the left.

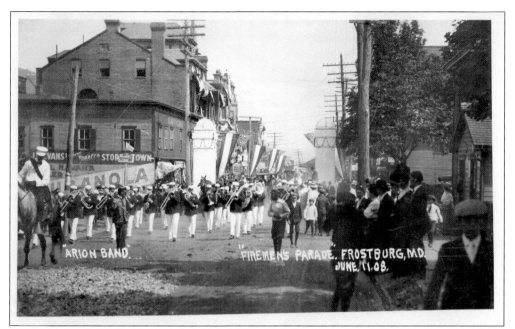

The German Arion Band of Frostburg, seen above on West Main Street in the June 11, 1908, Firemen's Parade, was organized in 1877 by Conrad Nickel, a native of Germany. It was formed from members of the German Arion Singing Society. This society primarily consisted of immigrants who settled in Frostburg, worked in the coal mines, and often had to provide their own entertainment. Upon securing enough instruments, the band began practicing, and in 1894, the group leased some land from the Consolidation Coal Company on Uhl Street and later built a band hall. The name "German" was dropped during World War I. The Frostburg Arion Band is thought to be the oldest continuous band of its type in America.

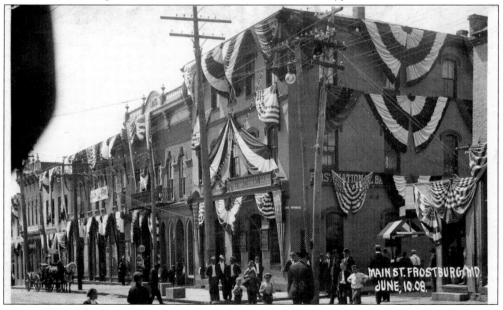

The sender of this June 10, 1908, postcard writes, "Will you come at least one day? The old town has turned herself loose."

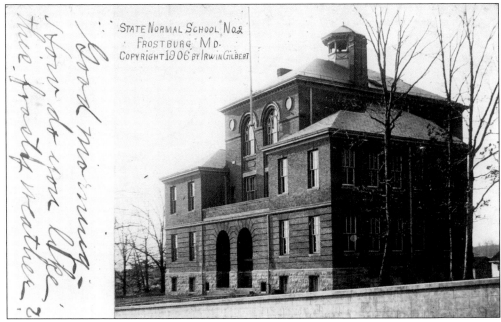

State Normal School No. 2 at Frostburg was established in 1898 by the Maryland Legislature. The state provided $20,000 to erect the school, but it was the citizens themselves, many of whom were miners, who raised the funds and secured a school site. The first building erected was Old Main, depicted above in this 1906 Gilbert photograph, which had its cornerstone laid in 1899. The school opened in 1902 and graduated its first class of eight students in 1904. The school became known as Frostburg State Teachers College in 1934 and Frostburg State College in 1963. On July 7, 1987, the institution was granted university status.

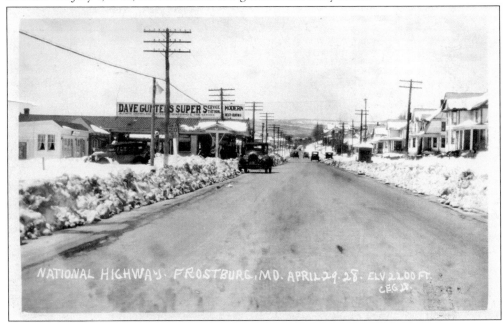

Below is a C. E. Gerkins photograph of East Main Street looking west during the famous snowfall of April 29, 1928. Dave Gunter's "Modern" Super Service Station is on the left.

The Citizens National Bank of Frostburg first opened in 1893 and was located in the old Opera House. The "modern, two-story, fire-proof bank building," seen here, opened in about 1912 and featured a luxuriously appointed 28-by-65-foot main banking room. In 1933, the bank went into receivership, and a new bank, Frostburg National, opened at the same location in 1934. The site is now occupied by the Susquehanna Bank.

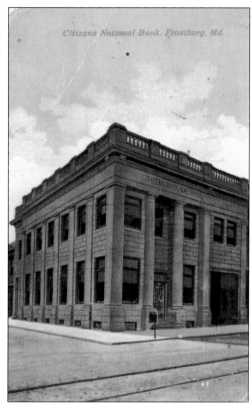

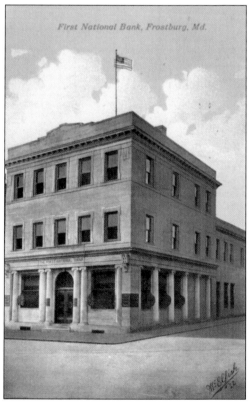

Organized in 1889, the First National Bank of Frostburg had by 1912 erected this new bank building on the southeast corner of Broadway and Main Street. The white-marble building featured 12 white marble support columns, bronze doors, and a main banking floor of Italianate marble. The bank prided itself on "conservative management," "safe and sane" business dealings, and an "impregnable vault." It closed in about 1933 and never reopened. (McElfish photograph.)

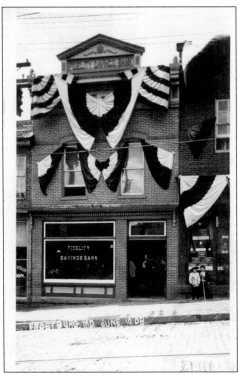

The Fidelity Savings Bank of Frostburg was opened in 1902. At the time of this June 10, 1908, photograph, taken during a Frostburg celebration, the bank was located at 61 East Main Street. The site later became the town parking lot and is now the present location of the Frostburg Community Library, one door east of the current Fidelity Bank building.

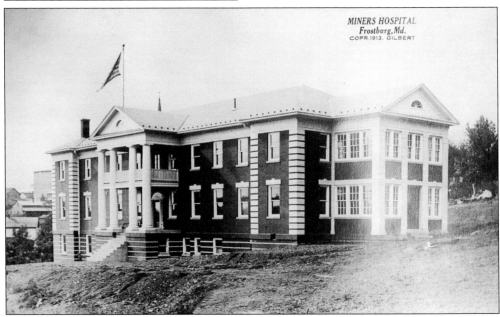

Construction began on Frostburg's Miners' Hospital in 1912. The hospital was officially opened in 1913, the same year as this photograph, with a female physician as the hospital's first superintendent. It later became known as Frostburg Community Hospital. The hospital closed in April 1995, and the site is now the Western Maryland Health System's Frostburg Nursing and Rehabilitation Center. The original hospital building, as seen in this Gilbert Studio photograph, was razed in June 1997.

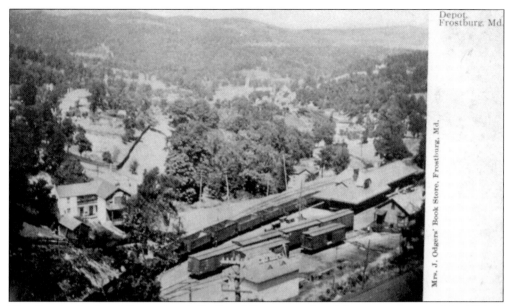

The Cumberland and Pennsylvania Railroad Depot, on the right, was constructed in 1891. It served as a passenger and freight station between Cumberland, Maryland, and Piedmont, West Virginia. By 1973, then under Western Maryland Railway ownership, the depot had closed and been abandoned. On the left is the Tunnel Hotel, which was constructed about 1888. It provided inexpensive accommodations, had an "unsavory" reputation, and during Prohibition was said to house a moonshine enterprise.

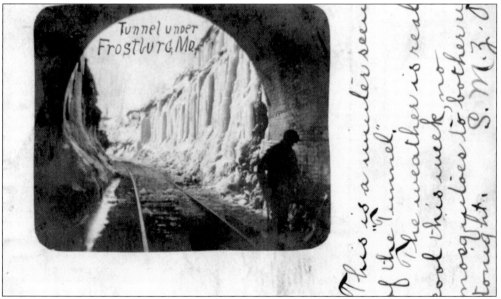

The railroad had reached Frostburg in 1852, and by 1857, the "C&P Tunnel" had been constructed at a length of over 500 feet beneath Frostburg. This connected the Cumberland and Pennsylvania Railroad to the rich George's Creek coal region. The sender of this June 27, 1905, postcard writes, "This is a winter scene of the tunnel. The weather is real cool this week. No mosquitoes to bother us tonight."

The United Church of Christ on East Main Street is the area's oldest church building. It was built by the Frostburg English Lutheran Congregation in 1845–1846. In the early 1850s, a German-speaking congregation shared the church with the English Lutherans. When a new Lutheran church was erected in 1863, this church was eventually deeded over to the German Evangelical Lutheran Zion Church for the sum of $1,000. An 1880s remodeling added a spire and large stained-glass windows.

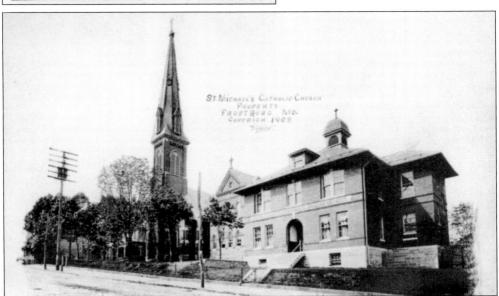

Shortly after 1850, the Catholic church purchased a site known as Highland Hall, the original homestead of Frostburg's founders, Meshach and Catherine Frost. After St. Michael's Catholic parish came into formal existence in 1852, portions of Highland Hall were remodeled for worship. The present church was erected in 1868–1870. It once had the town's tallest spire, but it was removed because of, as some say, Frostburg's fierce winter winds. The school, seen here in 1908, was erected in 1891. (Gilbert photograph.)

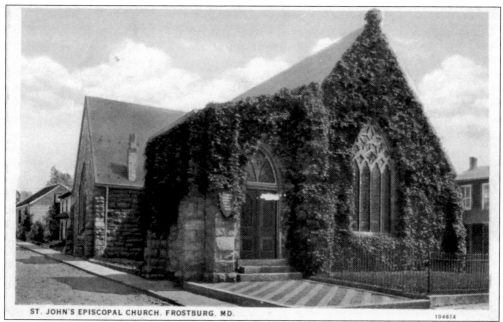

ST. JOHN'S EPISCOPAL CHURCH, FROSTBURG, MD.

104614

The Episcopalians were holding worship services in the Frostburg area as early as the 1840s. In 1853, a congregation was organized, a charter secured, and the name St. John's chosen. The present church site on Broadway, depicted above, was purchased in 1854. The congregation apparently utilized an old schoolhouse that stood upon the lot at the time of purchase. The present stone St. John's Episcopal Church was built in 1890–1891 with walls two feet thick. The first service was held here on September 1, 1892, with the church building, by now free of debt, being consecrated on June 17, 1902. The tower, not depicted here, was added in the 1920s at a cost of $3,420.

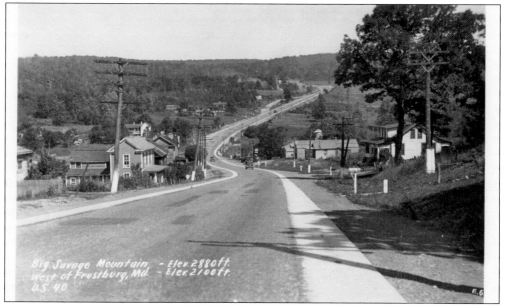

Big Savage Mountain - Elev 2880 ft.
West of Frostburg, Md. - Elev 2100 ft.
U.S. 40

Depicted here is a C. E. Gerkins view of West Main Street, looking west toward Big Savage Mountain.

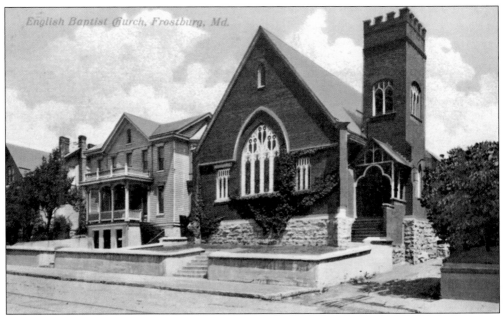

The First English Baptist Church, depicted above, was organized in 1871. A white frame church was soon erected. The present brick structure was built on Main Street in 1905. The old church, which stood on the rear of the lot, was razed in 1907 and a parsonage erected. A church remodeling in 1931 removed the exterior steps and provided a street-level entrance. In 1952, a nearby property was purchased for use as a new parsonage until 1973, when the present parsonage was built. The church tower is now gone.

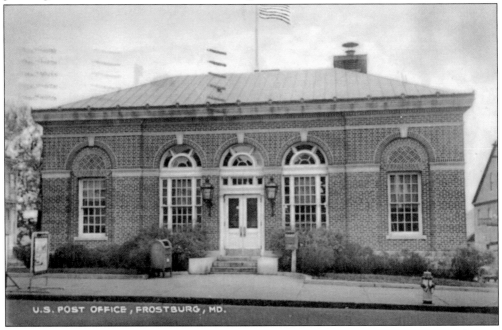

About 1911, Congress appropriated $50,000 for the purchase of a lot and construction of a new Frostburg Post Office. Shown in this 1951-postmarked view, it stands at the corner of Main and North Water Streets. The sender writes, "I never saw such high mountains."

The Methodists of Frostburg organized in 1832 and built their first of several churches in 1835. This was upon the same site as the present Frostburg United Methodist Church at 48 West Main Street. Construction began on the present church in 1870 with the dedication on December 17, 1871. Built at a cost of $42,237, the church measures 167 feet to the top of the spire. The red-brick parsonage, east of the church, was completed in 1892 at a cost of $4,000.

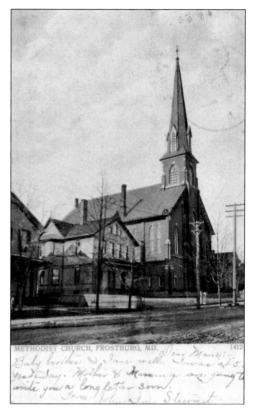

St. Paul's Lutheran Church was organized as early as 1812, making it the oldest established congregation in Frostburg. The church site at 34 West Main Street was secured in 1859, with a church completed and dedicated here in 1863. In 1874, the original church structure was gutted by fire, and the present church, as seen in this 1911 postcard view, was dedicated on April 20, 1879, with the steeple being added in 1883.

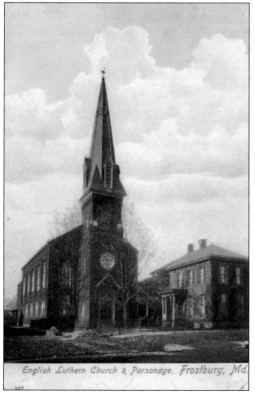

89

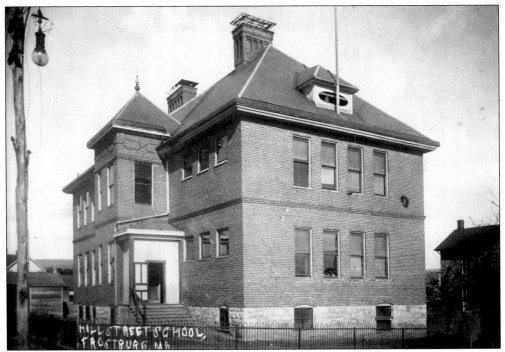

The Hill Street School was constructed in 1899 and served eastern Frostburg. It originally consisted of six rooms with about 300 students and a faculty of five with a teaching principal. A 1914 expansion added two additional toilets, an auditorium, recreation hall, and extras classrooms. Prior to 1915, the school served grades one through eight and, after that year, grades one through six. The school closed in 1976 and is now home to the Frostburg Museum.

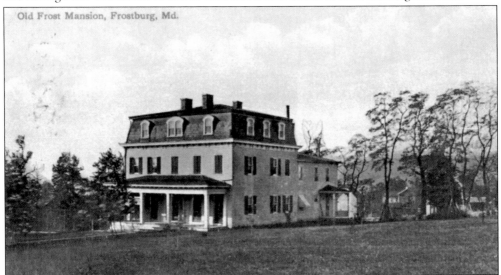

Old Frost Mansion, Frostburg, Md.

The Frost Mansion on Frost Avenue, as seen in this view postmarked 1912, was constructed in 1846 by the founders of Frostburg, Meshach and Catherine Frost. Their son, Nathan, who also served as Frostburg's first mayor, later added six rooms and a mansard roof. Nathan promoted the former farmhouse as a summer hotel attracting many important guests from the Washington and Baltimore areas. An 1888 advertisement notes the building had 17 rooms.

The Dreamland, a nickelodeon on East Main Street, opened as early as 1904. The building was purchased in 1911, extensively remodeled, and, upon the Palace Theatre Company's incorporation in 1912, held its grand opening as the Palace Theatre on June 11, 1913. The theater enjoyed wide notoriety until closing in 1981. After a short reprise, the Palace Theatre now serves the community for local theatrical productions, civic events, and film festivals. (Author photograph.)

The St. Cloud Hotel, seen here on June 10, 1908, during the Firemen's Convention, stood along the north side of Main Street just west of Depot Street. Upon remodeling in 1887, the hotel featured a 100-seat dining room, over 20 hotel rooms, and, for the convenience of its clientele, a bathroom at the end of each hall. The hotel was owned by Meyer Gerson (the author's grand-uncle) from about 1917 until it burned in the late 1920s.

The original Beall High School was first known in 1895 as Public School Number One. Located on East Loo Street, now College Avenue, the school was built in 1893–1894, cost $20,000, and included 10 classrooms, a library, and 2 assembly halls. A large, two-story addition in 1910 added classrooms, a gymnasium, and a physics and chemistry room. It became an elementary school in 1941 after the erection of a "new" Beall High School and was razed in 1975.

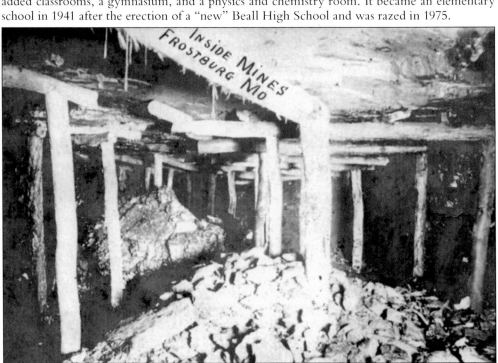

Entitled "Inside Mines Frostburg, MD," this postcard is dated February 4, 1905. One year later, in 1906, the *Coal Trade Journal* would report that the average number of days worked for an adult coal miner in Maryland would be 250. The average annual income was $489.97. Not included in this figure were the varied costs of living: room and boarding fees, company home rents where applicable, and the company store.

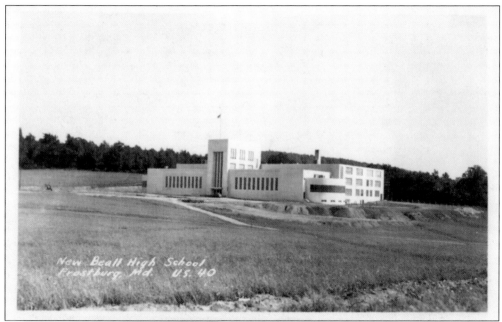

The "new" Beall High School opened in January 1941. The athletic field does not appear above because it was not in the original plans. Community pressure resulted in land being purchased in front of the school. It would take over three years and thousands of dollars raised from the community and alumni to complete the athletic facility. In 1969, a junior high school connected to the high school by a cafeteria was opened, and in 1984, the school was renovated with a new brick facing. A new high school, the Mountain Ridge "Miners," is presently under construction at the site with the current high school scheduled for razing within the next year. Approximately 12,000 students will have graduated from Beall in its 110-plus-year history.

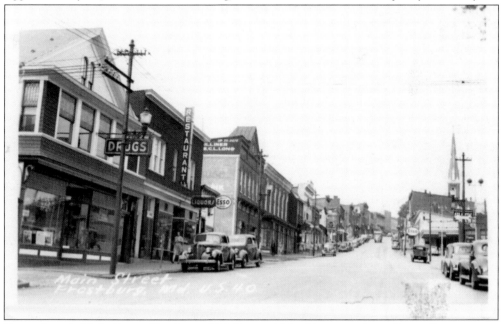

Shown here is Main Street, Frostburg, U.S. Route 40 looking west from Center Street.

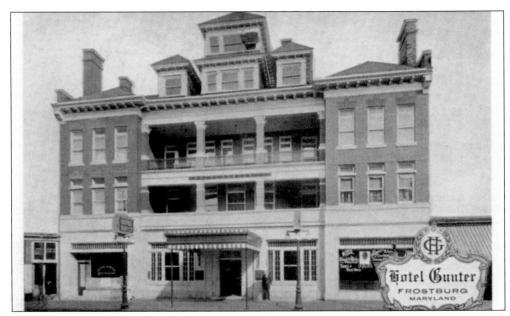

The Hotel Gladstone, depicted above, was built in 1896 at a cost of $125,000 and opened on New Year's Day, 1897. The hotel featured 100 rooms, a café, barbershop, and an observatory on the fifth floor. The Gladstone, later known as the Hotel Gunter in 1920 after its purchase by William R. Gunter in 1903, became a major summer destination point on the National Road and during World War I provided free rooms to soldiers passing through the area. Now known as Failinger's Hotel Gunter, the hotel has been restored in recent years.

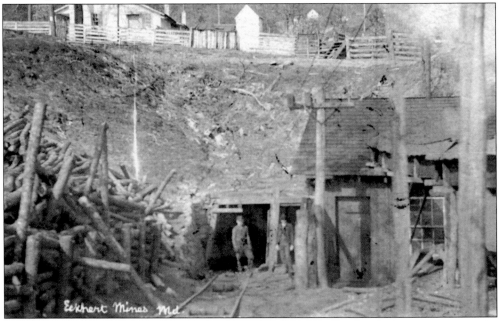

This 1908 postcard view depicts Eckhart Mines. Note the stack of wood mine props on the left. By 1852, the village of Eckhart Mines contained approximately 100 structures of wood, brick, and stone. Among these were 70 dwellings that housed somewhere between 700 and 800 people.

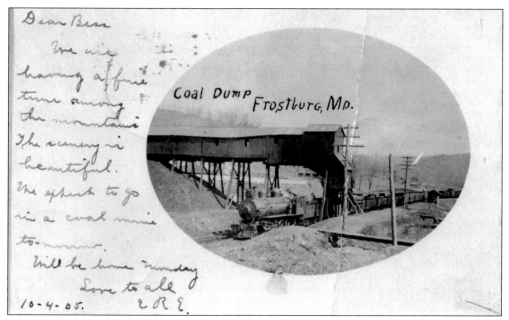

Dear Bess

We are
having a fine
time among
the mountains.
The scenery is
beautiful.
We expect to go
in a coal mine
to-morrow.
Will be home Monday
Love to all
10-4-05. E R E.

Coal Dump Frostburg, Md.

C&P Railroad Engine No. 61 stands ready at a coal dump in Frostburg. This particular engine was built at Mount Savage in 1899, had 50-foot drivers, and weighed 148,500 pounds. The sender of this October 4, 1905, postcard writes: "Dear Bessie, We are having a fine time among the mountains. The scenery is beautiful. We expect to go in a coal mine, tomorrow. Will be home Monday. Love to all."

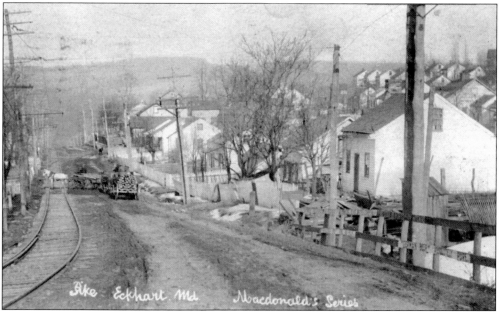

Pike - Eckhart, Md. Macdonald's Series

This is the "Pike" as it appeared going through Eckhart Mines from a postcard dated April 17, 1908. Note the trolley car tracks of the Cumberland and Westernport Electric Railway Company on the left, the two horse-drawn wagonloads of wood mine props, and the many coal company homes across the hillside of this former coal company town. An advertisement on the wooden railing on the right reads, "German Beer, Absolutely Pure."

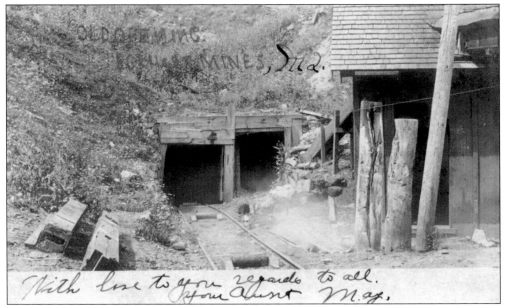

Eckhart was originally laid out in 1789. It was during the construction of the National Road through the area in 1815 that rich coal deposits were uncovered. The Maryland Mining Company led to the establishment of Eckhart Mines as a coal town. This 1906 postcard of an "Old Opening" at Eckhart Mines reads, "With love to you, regards to all, your Aunt Mary."

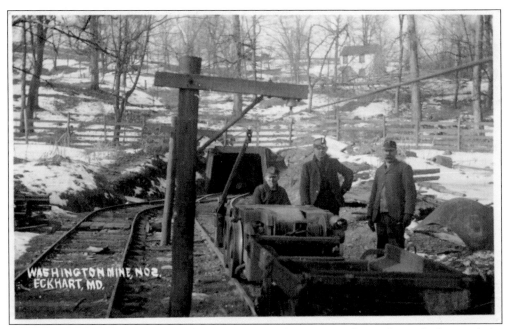

By 1910, Hungarians, Poles, Swedes, Russians, and, in particular, Italians, had joined the earlier Scots, Irish, Germans, English, and Welsh in immigrating to far Western Maryland and working its mines. The 1910 census showed the total number of mine workers in Allegany and Garrett Counties as being 5,798. This scene, from about 1908, depicts Washington Hollow Mine No. 2 in Eckhart.

Four

GEORGES CREEK

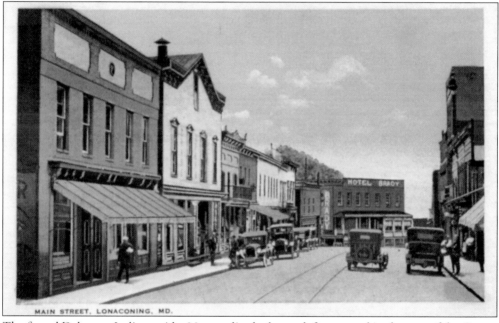

MAIN STREET, LONACONING, MD.

The famed Delaware Indian guide, Nemacolin, had a son left as a ward in the care of the Cresap family. The youth was given the Christian name George, and the present-day Lonaconing area was his hunting domain; hence the name Georges Creek. Some say the name Lonaconing is a derivation of the Native American word *Aliconie*, which translates to mean "people of the mountain streams" or "meeting place of many streams." Others say it was named for a long-ago chief, Lonacona. One scholar writes that the name Lonaconing is more correctly derived from several Delaware-Algonquin words and can be translated to mean "where it disappears from view" or "where there is a beautiful summit," both being a possible reference to nearby Dan's Rock or Dan's Mountain. The Hotel Brady, in the background, replaced an earlier wooden frame structure erected by James T. Brady that had been destroyed in the Great Fire of Lonaconing in 1881. Ironically many of the frame buildings depicted on the left were destroyed by a fire in 1990.

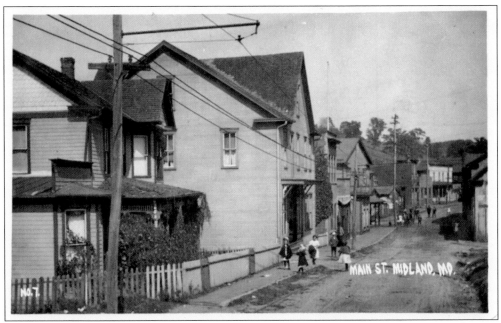

The town of Midland, whose Main Street is depicted above in a 1908-postmarked view, was originally known as Koontz after an early settler who had come into the area in the early 1800s. Coal was the major local industry, with the first mines opening in the area before 1850. The coal industry was served by the Cumberland and Pennsylvania Railroad, as well as the Georges Creek and Cumberland Railroad, which completed its line in 1881. Trolley cars from the Cumberland and Westernport Electric Railway line also traveled Main Street in Midland, as well as other main streets throughout Georges Creek. Depicted below is Midland's Hotel Bowen as seen from a Gilbert postcard dated 1907.

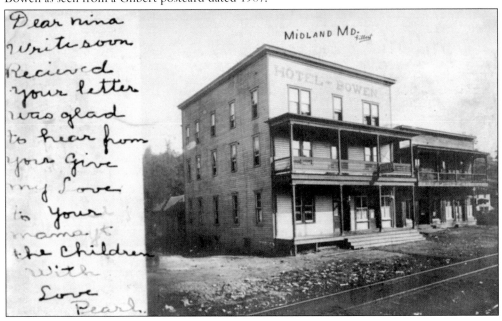

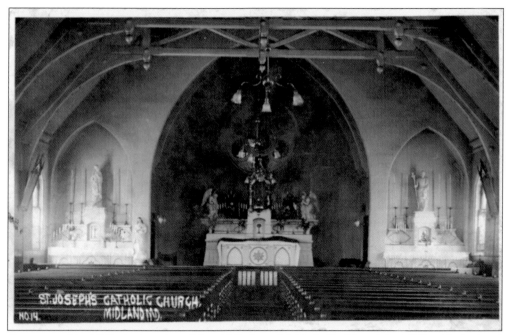

Constructed in 1891, the interior of the old St. Joseph's Catholic Church in Midland is depicted in the above 1908 postcard. A new St. Joseph's was dedicated in 1967.

One day, Daniel Cresap and the famed Nemacolin were hunting bear. They treed some bear cubs, and as Daniel climbed after them, a limb broke and he fell to the rocks below, breaking several bones and becoming unconscious. Nemacolin transported him home on a litter, and the ridge where he fell became known as Dan's Rock. Years later, Daniel was pursuing a Native American on that mountain. Both shot at each other simultaneously, and both were mortally wounded. The mountain became known as Dan's Mountain.

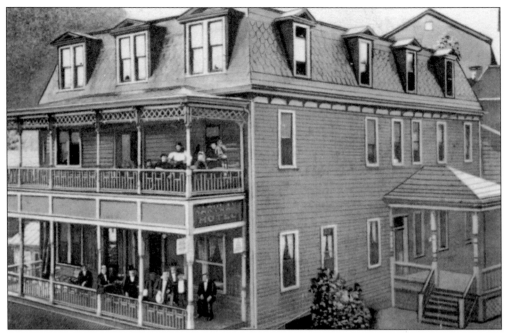

The sender of this 1909-postmarked view of the Maryland Hotel in Lonaconing writes: "Hello Mary, I know this place can beat Salem for it is just fine. I hope you will have a happy 4th of July. Now don't work to hard and don't sell all my neckwear fir I will not have a job if you do. Good-bye, Lizzie."

The Jackson Street School was constructed in 1893. Its primary purpose was to relieve the overcrowded conditions occurring at Central Elementary School. Jackson Street was a two-story building with six classrooms, an office, basement, and furnace for cold weather. It also featured indoor plumbing, and this was something the town was very proud of. The elementary school served grades one through six and serviced the community until 1953.

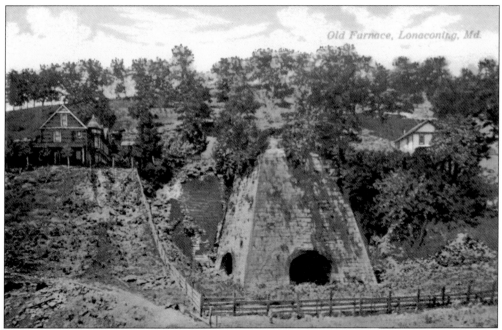

Old Furnace, Lonaconing, Md.

The Lonaconing Iron Furnace, seen above in 1913, was constructed in 1837 by the Georges Creek Coal and Iron Company with the first run of iron made in 1839. With the coming of the Georges Creek Coal and Iron Company in the 1830s, the "hub of the crick" Lonaconing began its climb as a town and commercial center. Between the years 1839 and 1844, the iron furnace was responsible for the employment of 260 workers and the production of 60 to 75 tons of pig iron per week. Castings included stoves, farm implements, and dowels for the C&O Canal lock walls. The Lonaconing Iron Furnace is 50 feet high and 50 feet square at the base. Iron production ceased around 1855 because of imported iron and the growing profitability of the company's coal trade. Below is a very-early-1900s view of Union Street.

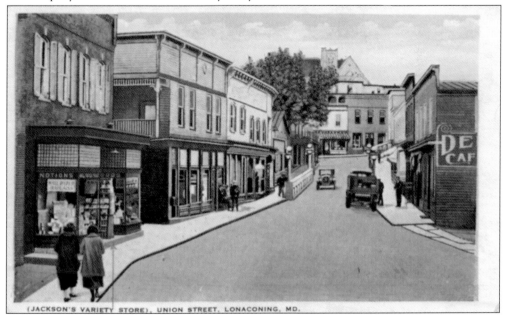

(JACKSON'S VARIETY STORE), UNION STREET, LONACONING, MD.

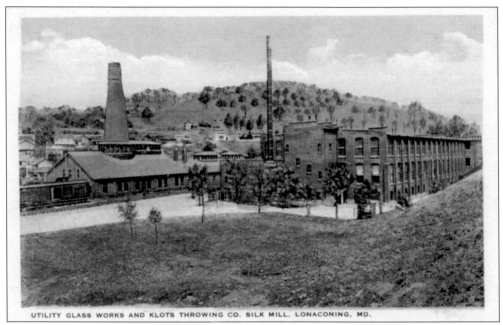

UTILITY GLASS WORKS AND KLOTS THROWING CO. SILK MILL, LONACONING, MD.

On the left is the Lonaconing Glass Company. Incorporated in 1914, at the time of its fiery destruction in 1932, it employed 220 people and was known as the Sloan Glass Company. Construction began in 1905 on the Klotz Throwing Company silk mill, shown on the right, and in 1907, the mostly female employees earned wages of $3.50 per week. The mill processed raw Japanese silk into thread and employed up to 300 people prior to its closing in 1957.

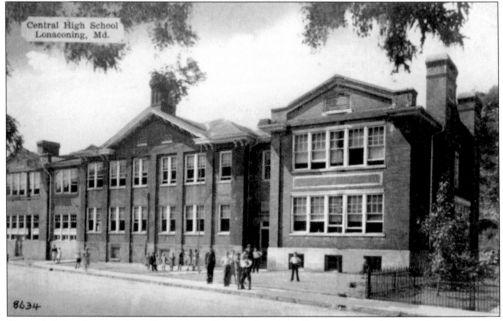

Central High School
Lonaconing, Md.

8634

Central School opened in September 1890 and originally served grades one through eight. By 1902, it had become a high school and underwent several expansions. The high school closed in 1953, and Central Elementary School opened in the former high school building. The elementary school closed in 1975, with the building being razed in about 1977.

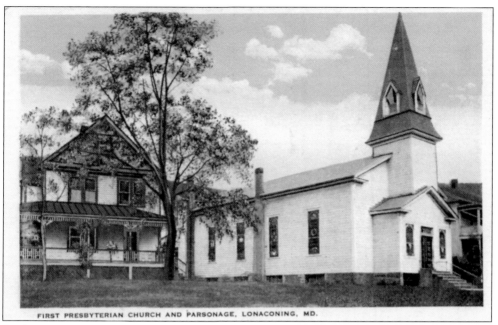

FIRST PRESBYTERIAN CHURCH AND PARSONAGE, LONACONING, MD.

Presbyterian activity in Lonaconing can be documented as far back as 1853, but not until 1861 would a church be officially established. The First Presbyterian Church was dedicated in 1867 at a construction cost of $3,000. The parsonage, built at a cost of $2,500, was completed in 1868. Between 1893 and 1907, a new manse was built, stained-glass windows added, iron fence erected, and cement walks and steps laid to the church entrance.

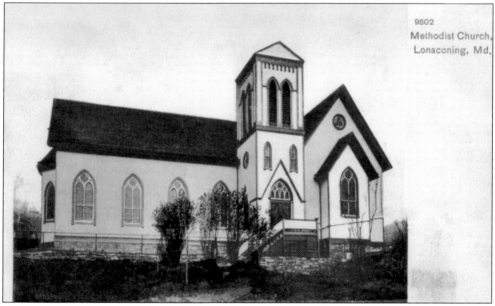

9802
Methodist Church,
Lonaconing, Md.

Prior to the construction of a small log meetinghouse in 1838, the Methodists of Georges Creek often met in private homes for worship. The present First United Methodist Church, seen here in a postcard view dated 1910, is a large frame structure known as the "church on the hill." It was dedicated in 1873 and built at a cost of $15,000. The church membership at that time stood at about 170 persons.

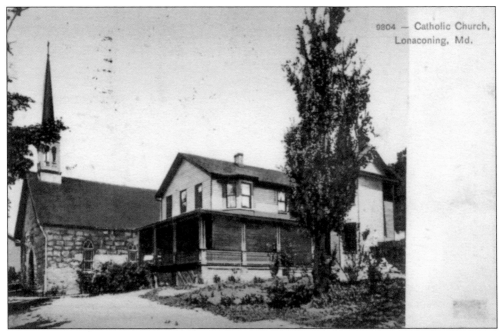

Between 1840 and 1866, Redemptorist priests serviced the Catholic community of Lonaconing, many of whom were Irish immigrants attracted here by work in the coal mines. The St. Mary of the Annunciation Church, shown in a 1907 postcard view, was built of stone and wood in 1865. A rectory and school soon followed, and in 1885, a convent was built for the sisters, who staffed a parochial school until 1907.

Reservoir, Lonaconing, Md.

This is the Lonaconing Reservoir, known to most as the Charlestown Dam. It was a popular swimming spot and meeting place and later provided an area for concerts and dancing. The sender of this 1913 postcard writes, "Well Jordan, I arrived home safe with the apples. They didn't get a chance to spoil as they were all ate up."

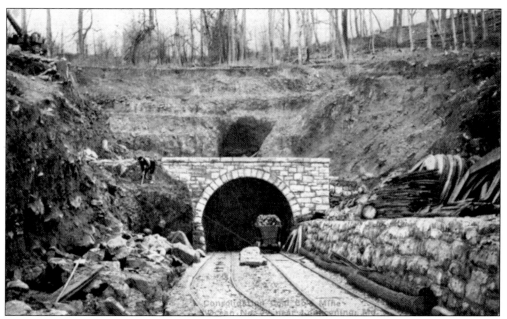

This is Consolidation Coal Company's Ocean Mine Number 7 at Klondike near Frostburg. This was a "slope" mine that Consolidation operated between the years 1897 to 1924. It accommodated two mine-car tracks and was an extremely productive mine. The Consolidation Coal Company operated in Maryland until 1944. The sender of this 1914 postcard writes, "One hour and thirty minutes from now I'll be riding a goat, Henry."

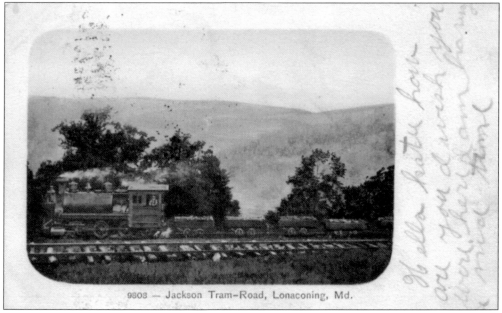

9808 — Jackson Tram-Road, Lonaconing, Md.

This view of the Jackson Mine Tram Road is postmarked 1908. A "tram," or tramcar, is an open railroad car used for transporting coal from the mines. It is being pulled by a "dinky," a small locomotive with no tender used for hauling cars short distances around the railroad or coal yard. In 1906, Maryland reached a record high of 6,436 miners, most employed in the Georges Creek Region.

This is a 1908 view of the American Coal Company's Jackson Mine Small Vein (inclined gravity) Plane, which served the mine and tram. In coal mines with narrower seams, the miners frequently worked on their hands and knees, often in cramped, damp, and dangerous areas. Natural ventilation was often supplied by air shafts dug into the mine, with the temperature underground varying somewhat with the conditions outside.

"Drift" mines, also commonly referred to as "punch" mines, such as the one seen here, were common in areas characterized by outcroppings of coal. This involved a horizontal entrance, sometimes called an "adit," dug directly into a surface coal seam or outcropping. Wooden timbers or props were used to support the mine entrance. The sender writes, "September 19th, 1907. Best Wishes to all, Ada." The postcard is titled Cutter Mine, Lonaconing, Maryland.

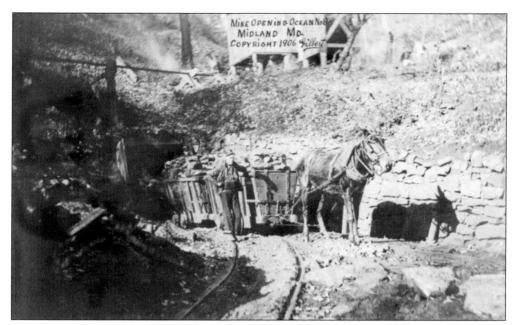

This 1906 Gilbert Studio photograph depicts the mine opening of Ocean Mine No. 8, just north of Midland at Ocean. The coal industry in Georges Creek was served by the Cumberland and Pennsylvania Railroad as well as the Georges Creek and Cumberland Railroad. Early mining was done by pick and shovel. Horses and mules pulled the hand-loaded trams or wagons from the mines to the railroad for shipment east.

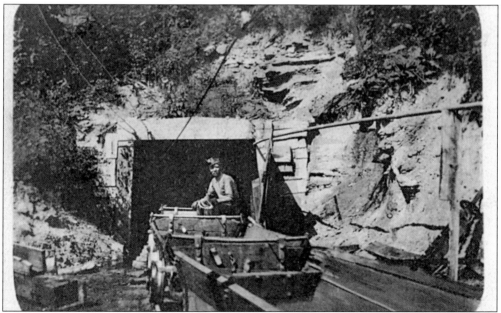

The population of Allegany County in 1870 was 38,536. About 20 percent of the county's population was born outside the United States. The 1870 census shows a total of 2,463 coal miners. Of these, there were 469 of English descent, 282 Welshmen, 654 Scotsmen, 369 from Ireland, 137 Germans, 56 British-Americans, 3 "other," and 493 of American origin. This 1900s view depicts Cone's Small Vein Mine.

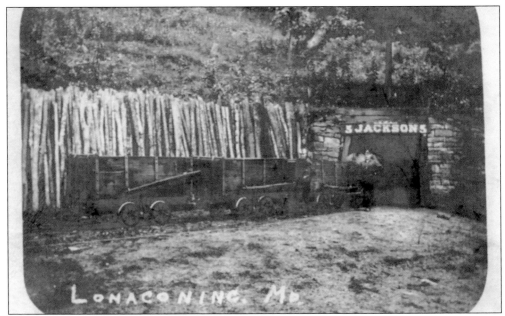

Above is the Jackson Mine No. 5 entrance as it appeared in 1908. Note the wooden props next to the mine opening. The sender writes, "My dearest wife, just to show you that I have not forgotten you, I send you these cards. This is a view of a small mine about 5 miles down the valley. The first time I go to Frostburg I will get some views of the Consolidation mines. That is where I work. The store here has run out of them. This card is for my little girls. I will send some views of Frostburg to them as soon as I can, Love, Charles."

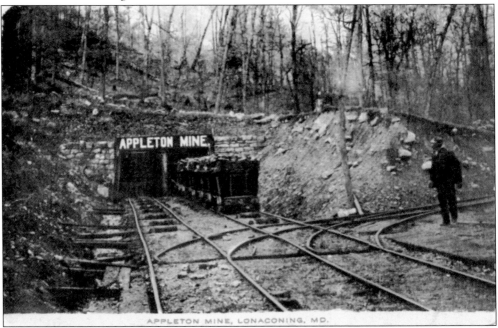

Below is a 1900s view of the Appleton Mine. Coal reigned as king in Georges Creek from 1850 until 1920. Consolidation remained a major employer into the 1930s with over 800 miners in its employ.

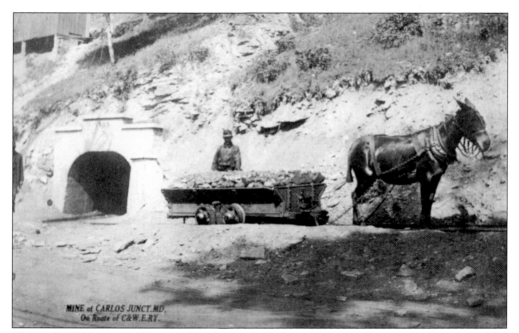

This early-1900s postcard view of a mine at Carlos Junction notes that it is on the route of the Cumberland and Westernport Electric Railway. By 1900, almost 5,000 men worked in the deep mines of Georges Creek. During the 1920s, the coal industry began its gradual decline due to replacement fuels such as oil and gas, labor shortages, and union problems. Surface mining totally replaced deep mining by the early 1960s.

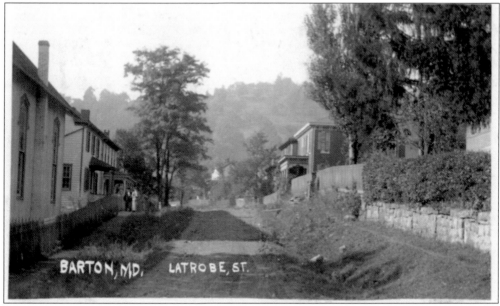

The Reverend William Shaw was born in Barton-on-Humber, England, and came to America as a young man. He traveled throughout Allegany County ministering to the needs of the people. In 1853, in anticipation of future development and the growing coal industry, Maj. William Shaw, the son of the Reverend Shaw, laid out and established a town called Barton, seen here in 1908, in honor of his father's birthplace in England.

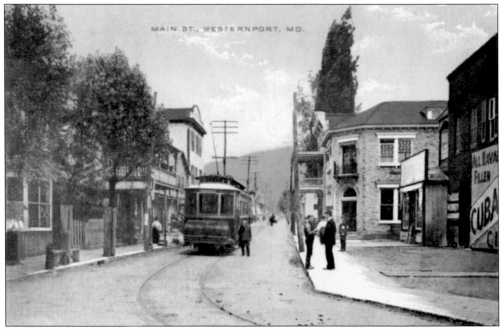

Although history books state that the town of Westernport was incorporated by an act of the Maryland Legislature on February 23, 1859, official town and state records cite the year as 1858. The community was originally known as Hardscrabble and had acquired a post office as early as 1802. It was named Westernport because it was, for flatboats only, the westernmost navigable port on the Potomac River. As seen above in this 1912 Main Street view, the town was served by trolley cars of the Cumberland and Westernport Electric Railway. This company resulted from several mergers and by 1905 had track running from Cumberland through LaVale to Frostburg and down the Georges Creek valley to Westernport. The bank building on the right is the old Citizens National Bank, erected in 1901. Below is a somewhat later view of Main Street.

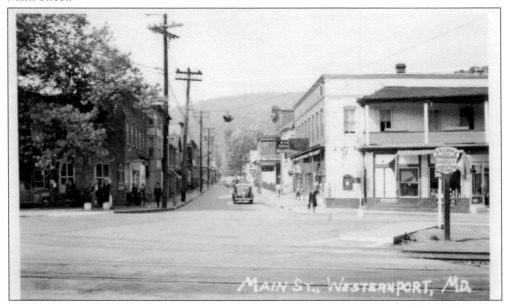

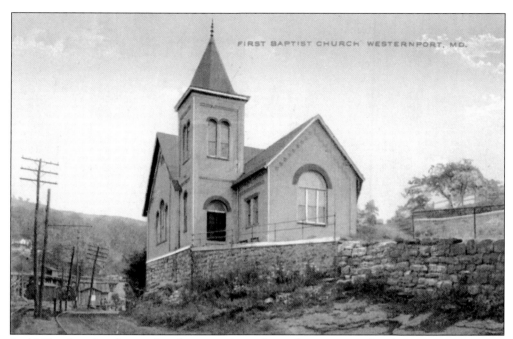

In 1905, planning began for the provision of worship services for the Westernport area Baptist community. Just three months later, on February 11, 1906, the First Baptist Church of Westernport, Maryland, was officially established. The cornerstone of the First Baptist Church was laid on November 8, 1908. The site upon which the church stands is said to have consisted of mostly solid rock. Constructed of gray sandstone bricks from Ohio, "The Church Upon The Rock," as depicted above in a view postmarked 1913, was officially dedicated on June 20, 1909.

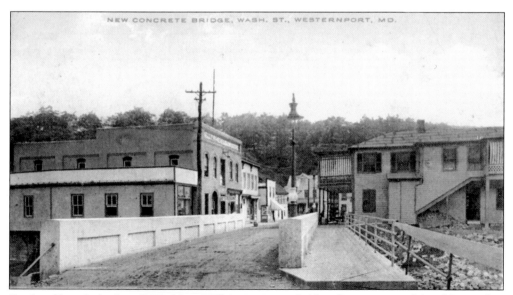

Depicted here is the "new" Washington Street concrete bridge, from a postcard dated September 10, 1912.

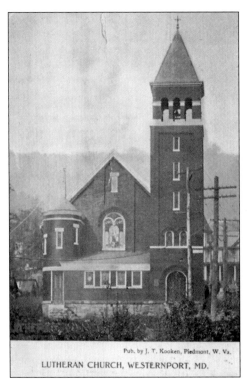

LUTHERAN CHURCH, WESTERNPORT, MD.

Before the Civil War, the Lutherans of Piedmont and Westernport were serviced by a minister who traveled Georges Creek from Frostburg. By 1869, steps were taken to establish a congregation, and in 1875, the Mount Calvary Evangelical Lutheran Church of Westernport, Maryland, and Piedmont, West Virginia, was formed with its incorporation in 1879. The church, shown in 1909, cost $2,113.72 and was dedicated in 1879. An 1897–1898 renovation included stained-glass windows and the tower construction with entrance.

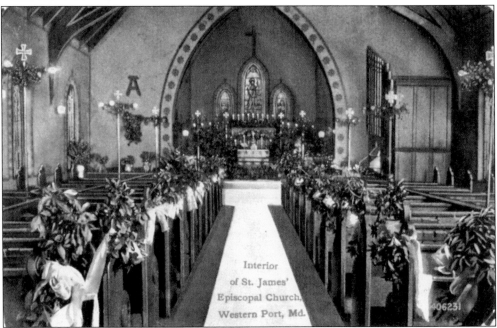

Interior of St. James' Episcopal Church, Western Port, Md.

For years, the Episcopalians living within the Westernport and Piedmont region had worshiped in private residences and public buildings or utilized the facilities of other congregations. Construction began on the present St. James Episcopal Church, seen here in 1913, in 1877. The church initially had no pews, and the congregation sat upon planks laid upon wooden crates. Electric lights were installed in 1919.

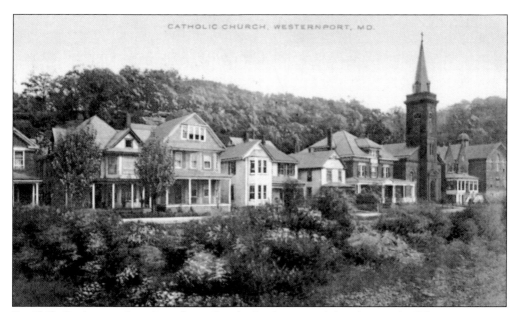

By 1849, Redemptorist priests from Cumberland were ministering to the Westernport area Catholic population, many of whom were Italian and Irish immigrants who worked the B&O Railroad or coal mines. St. Peter's Roman Catholic Church, shown in 1913, was built during 1870–1872 at a cost of $25,000. The parish school (far right) was built in 1905, the convent (second from the right) in 1873–1875, and the rectory (fourth from the right) in about 1898.

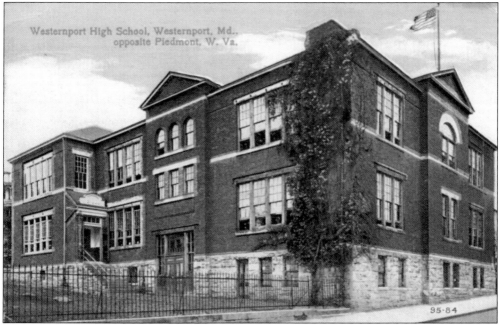

The Hammond Street School, depicted above in 1917, was opened in 1923. It initially served about 600 students in grades one through eight. The school eventually closed in 1957, and classes were relocated to the former Bruce High School on Church Street, which had been vacated and renamed Westernport Elementary. This occurred with the building of a new Bruce High School on Philos Avenue in 1957.

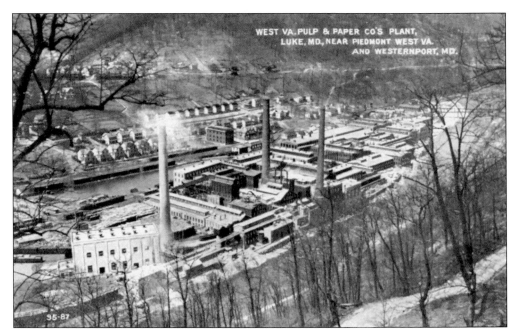

The Piedmont Pulp and Paper Company of Allegany County in West Piedmont (now Luke) was founded in 1888. After several small local mergers, it was renamed in 1897 as the West Virginia Pulp and Paper Company, and in 1969, it became known as Westvaco. In 2005, the paper corporation became known as NewPage.

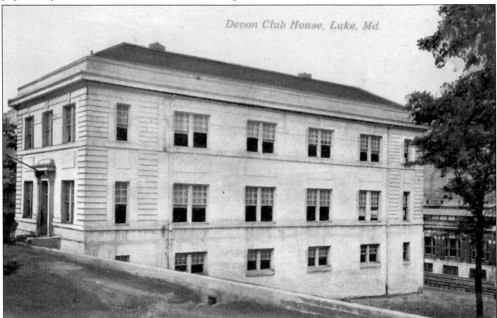

The Devon Club of Luke was a gathering and meeting place for residents of Luke and employees of the West Virginia Pulp and Paper Company. It featured a large auditorium that held stage shows, smokers, and card tournaments. The club also sponsored area baseball teams. The building exists today and is still being used by the paper company to house the Design Engineering Offices.

Five

ALLEGANY COUNTY-WIDE

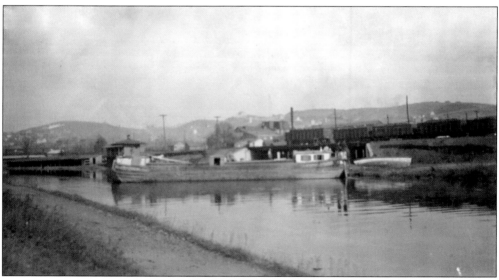

On July 4, 1828, Pres. John Quincy Adams broke ground in Georgetown for the 184.5-mile Chesapeake and Ohio Canal. Eleven stone aqueducts, 7 dams, 1 tunnel, and over 70 lift locks would go into the construction prior to its completion to Cumberland and opening on October 10, 1850. At the Cumberland terminus, canal boats were unloaded and returned east with cargoes of coal, flour, grain, and timber. Canal boats were 92 feet long, 14-and-one-half feet wide, and capable of transporting 120 tons of cargo on the 4–6 day journey to Georgetown. A team of Kentucky mules was required for the trip, with at least two working a six-hour shift while the others rested on-board. In 1924, two major floods devastated the canal, and it ceased operations permanently. This 1916 Joseph Meyers canal boat photograph at the Cumberland terminus depicts the mule stables on the left and coal-laden rail cars on the right. In 1971, the Chesapeake and Ohio Canal was named a National Historical Park.

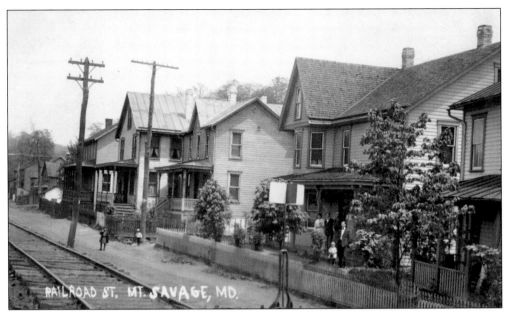

Depicted above is Railroad Street. Known today as Mount Savage, this community was in 1780 referred to as "Arnold's Settlement," after Archibald Arnold. Located along an old Native American path known as "Turkey Foot Road," it served as a stop for travelers moving westward to the Ohio River. The area had rich mineral deposits, such as coal, iron, and clay. A rolling mill was established in 1839, and in 1844, the mill produced the first iron railroad rail in America. The New York Iron and Coal Company called this "Iron Works," Mount Savage, because of its location at the foot of Savage Mountain. Iron, brick making, coal mining, and railroading characterize Mount Savage history.

This is a 1907 depiction of the St. George's Episcopal Cemetery. The sender writes, "The monument on the left is where my relatives are buried. The house 'marked' is the one we built last summer."

116

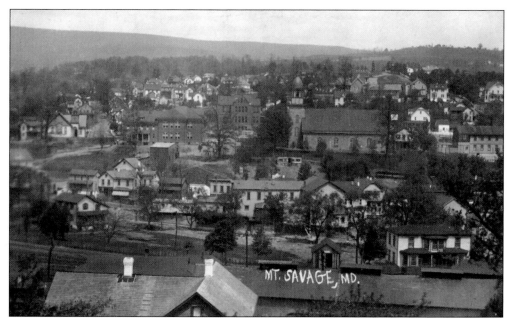

The first mass celebrated in the Mount Savage area was conducted in 1793 by Fr. Stephen T. Badin, the first Roman Catholic priest ordained in America. By 1835, St. Ignatius Church was erected, and in 1863, the cornerstone was laid for a new church about one mile distant. It was named St. Patrick in recognition of the numerous Irish immigrants. St. Patrick's Catholic Church, as seen above in the middle of this 1907 view, was formally dedicated on October 5, 1873. In 1892, with over 2,500 people in attendance, the new bell in a belfry surmounted by massive gilt cross was blessed. In 1896 land adjacent to the church was acquired for a school and convent. St. Patrick's School, depicted below, was constructed in 1900 and served grades one through eight until its closure in 1969. It was razed in 2001.

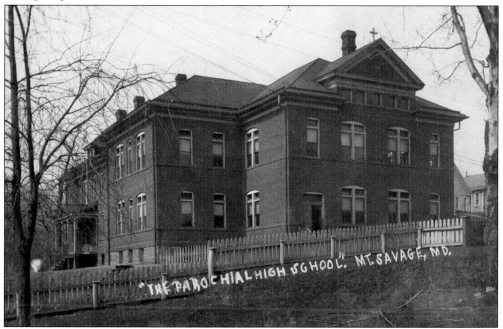

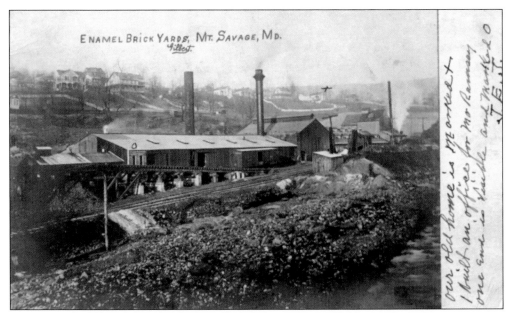

ENAMEL BRICK YARDS, MT. SAVAGE, MD.
Gillet.

Our old home in market. I built an office for Mr Ramsay one end in Vaudle and Markt O JET

In 1895, Andrew Ramsay founded the Mount Savage Enamel Brick Company, which manufactured a magnificent enameled glazed brick. Ramsay's bricks and other products were world-renowned for their beauty and durability, and they were shipped all over the western hemisphere. Business setbacks forced the company's mortgaging in the late 1920s. Ramsay died in 1932, along with the production secret for his bricks.

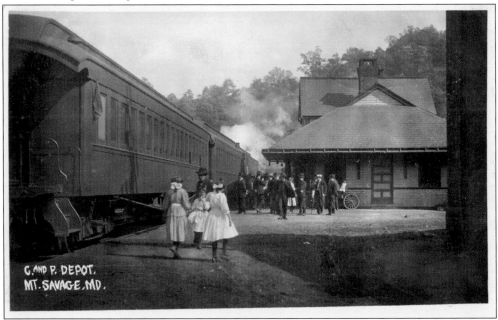

C. AND P. DEPOT.
MT. SAVAGE, MD.

The Cumberland and Pennsylvania Railroad was the county's most enduring short line. Built 1844–1846, the C&P was incorporated in 1850. Its Mount Savage Shops were erected about 1865 and employed as many as 600 men. The shops closed upon the Western Maryland Railway's purchase of the C&P in 1944. The C&P Railroad Depot at Mount Savage was constructed in 1891 and painted Tuscan red. The depot was razed about 1955.

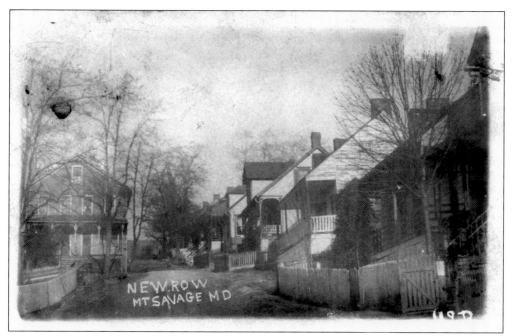

The sender of the March 22, 1911, postcard above depicting New Row in Mount Savage writes, "I arrived at Cumberland 1:30 and here at 4 P.M. Am going to supper and the shops."

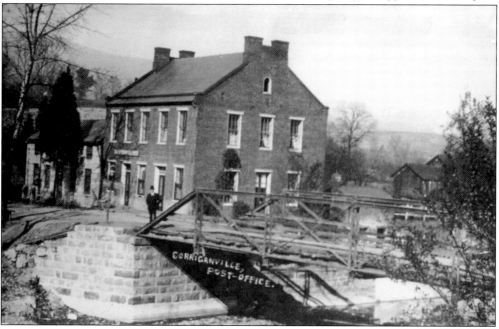

Matthew Corrigan came to America from Ireland in about 1869 and located in a small village called Kreigbaum. The first post office was soon established with Matthew as its first postmaster, and the name Kreigbaum was changed to Corriganville. The Corrigan Brick Tavern, depicted here, is located on the Old Plank Road (now old Route 36) in Corriganville. Built in 1860, the tavern provided not only drink and accommodations to the traveler, but it also served as a social center and post office for local citizens.

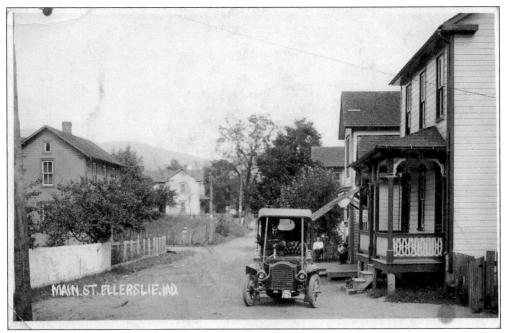

This is Main Street in Ellerslie, from a card postmarked 1914.

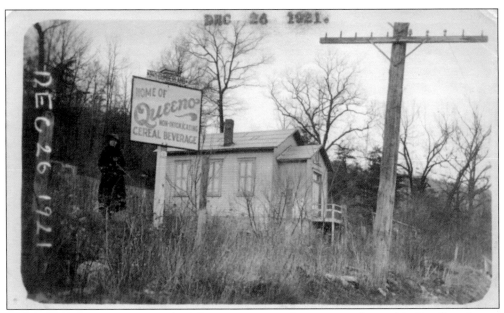

The Roberts School House was built between 1873 and 1881. It was located in Bowling Green, three and three-fourths miles south of Cumberland near the present Bowling Green Fire Hall and opposite Aspen Avenue. This Joseph Meyers photograph, taken on December 26, 1921, during Prohibition, advertises Queeno, a "non-intoxicating cereal beverage" sold by the German Brewing Company.

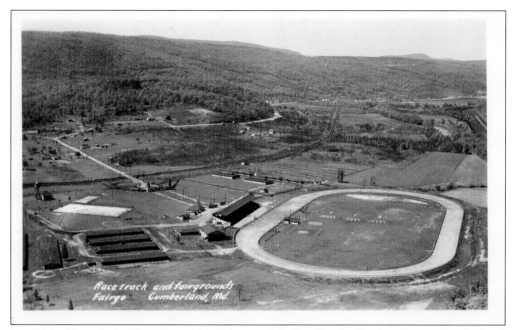

In 1924, "America's Most Beautiful Fairground," the Cumberland Fairgrounds, depicted above, was completed at a cost of $250,000. The fairgrounds was built on a tract of land along the Potomac River south of Cumberland and beneath the towering cliffs of Knobley Mountain. Opening day for the new racetrack was on October 7, 1924. The track featured horseracing, which was a popular attraction at "Fairgo" from the 1920s until the last horse race in September 1961.

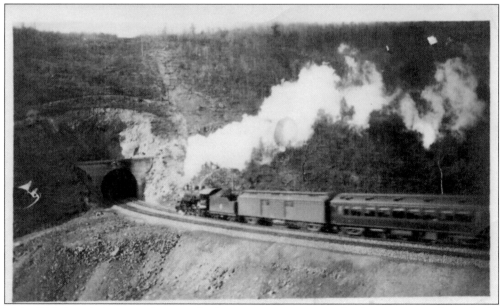

This 1915 Joseph Meyers photograph depicts a Western Maryland train going through the 912-foot-long Brush Tunnel, which opened in 1911. The route is now part of the Western Maryland Scenic Railroad and parallels the Allegheny Highlands Trail of Maryland.

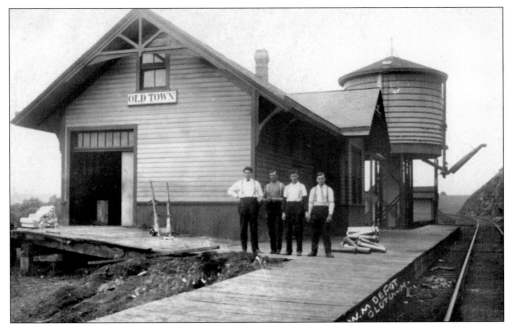

In 1709, Thomas Cresap came to America and Maryland from England. In about 1741, he constructed a home and stockade fort in what is now Oldtown upon an old Shawnee Indian village, known as "King Opessa's Town." This view depicts the old Western Maryland Railway Depot at Oldtown, where the Western Maryland had extended its line by about 1903. The Western Maryland had completed its line from Hagerstown to Cumberland in 1906.

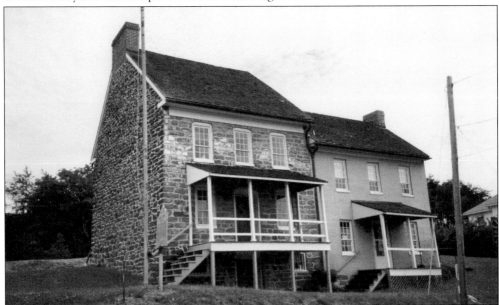

This was the home of the famous 18th-century frontiersman and American Revolutionary War officer Capt. Michael Cresap. In 1775, Cresap rallied and led his Western Maryland Volunteers to Massachusetts to join the Continental Army. He soon became ill, headed home, died en route, and was buried in Trinity Churchyard, New York City. The original stone house was constructed in about 1764, with the brick addition built in 1781. (Author photograph.)

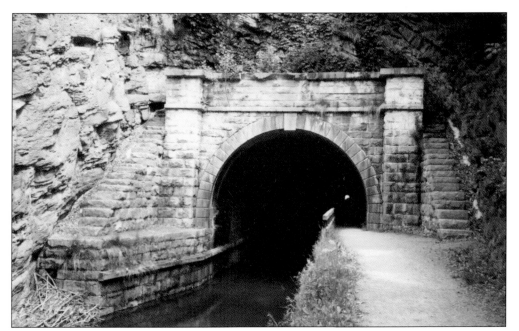

The Chesapeake and Ohio Canal wanted to cut construction costs, shorten travel time, and avoid the six-mile stretch of the Potomac River known as Paw Paw Bends. Therefore, construction began in 1836 on the 3,118-foot Paw Paw Tunnel. Labor problems, cholera, financing, and liquor led to turmoil and delay. This final link in the C&O Canal between Cumberland and Georgetown was opened on October 10, 1850, at a cost of $850,000. (Author photograph.)

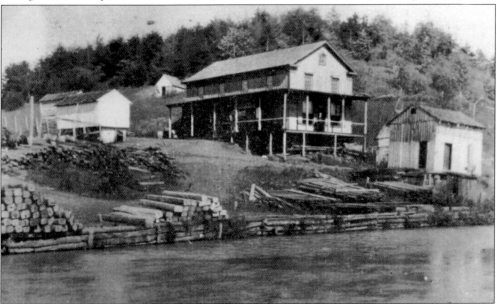

Postmarked 1982, this view depicts the Little Orleans Grocery. The back describes the store on the Chesapeake and Ohio Canal as originally being established in 1896, but it was moved to its present location in 1904 to make room for the Western Maryland Railway. The owners are identified in 1982 as Bill and Ethel Schoenadel. Destroyed by a fire in 2000, Bill's Place at Little Orleans was rebuilt the following year.

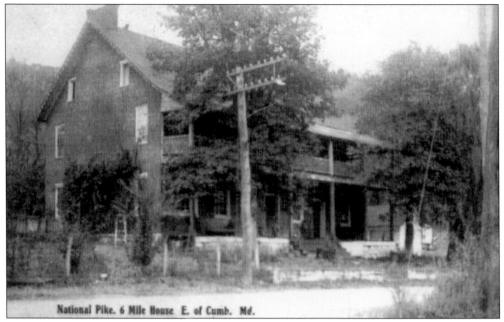

National Pike. 6 Mile House. E. of Cumb. Md.

The Six Mile House, built *c.* 1840, was a well-known mid-19th-century tavern stand and inn. It was located six miles east of Cumberland on the Baltimore Pike, also known as the National Road. In the 1960s, it became home to (Edward) Habeeb's Florist. The historic building is now occupied by Rocky Gap Gifts and Furnishings.

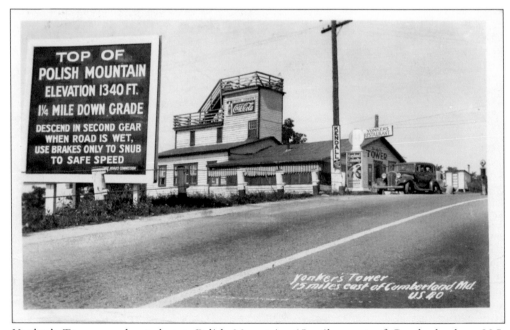

TOP OF
POLISH MOUNTAIN
ELEVATION 1340 FT.
1¼ MILE DOWN GRADE
DESCEND IN SECOND GEAR
WHEN ROAD IS WET,
USE BRAKES ONLY TO SNUB
TO SAFE SPEED

Yonker's Tower
15 miles east of Cumberland Md.
U.S. 40

Yonker's Tower was located atop Polish Mountain, 15 miles west of Cumberland on U.S. Route 40. As the sign says, "Descend in second gear when road is wet. Use brakes only to snub to safe speed." Postcards, pottery, souvenirs, Amoco gasoline, and home-cooked meals could all be had at Yonkers.

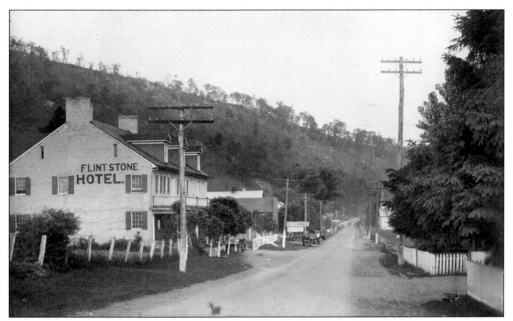

Built in 1807, the Flintstone Hotel served as a dwelling, stagecoach stop, and tavern stand along the National Road. The hotel hosted many notables, including the Marquis de Lafayette on his visit to America in 1824 and Theodore Roosevelt. The hotel was purchased in 1901 by Dr. Alvin Twigg and went on to gain wide popularity and patronage thanks to its proximity to the famed Mineral Springs of Flintstone.

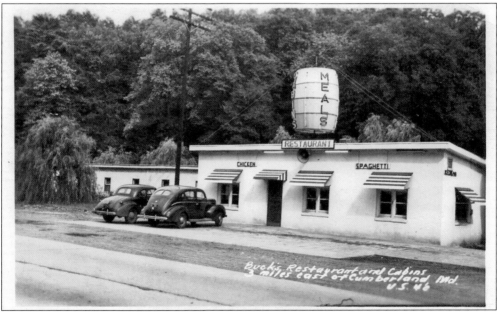

This was the "famous" Buck's Motel, cabins, and restaurant, located just two miles east of Cumberland directly on U.S. 40. A Buck's Motel postcard of the era notes that U.S. 40 is "The Historic National Old Trail" and is "America's longest, finest, and most picturesque toll-free highway." Buck's advertised clean, modern, beautifully located, popular price accommodations. One could just call Cumberland 5658.

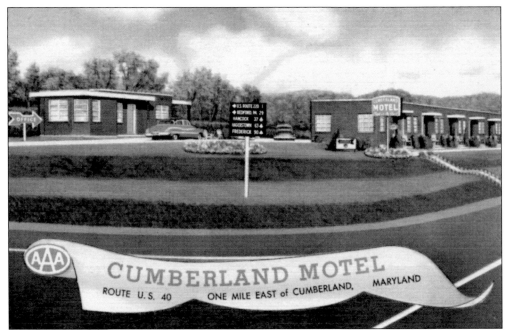

This postcard back notes the Cumberland Motel is located directly along the "National Old Trails" on U.S. 40, one mile east of Cumberland. The motel boasted brick construction, tile baths, fully carpeted rooms, and hot water heat with excellent club and food facilities nearby.

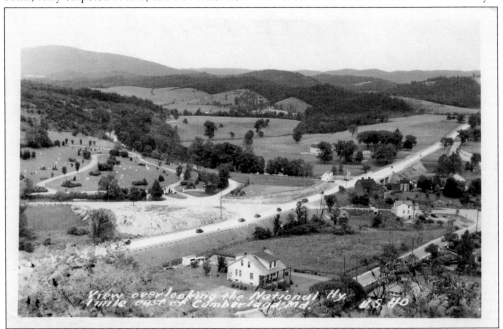

This 1947 postcard depicts old Route 40, one mile east of Cumberland. Taken prior to the construction of Mason's Barn and the Cumberland Motel, the photograph shows the Hillcrest Memorial Park on the left and the old Folck's Mill site, now in ruins, among the trees top right. The sender writes, "Dear Gramps, we were over this road this morning. So many beautiful mountains and sights. I'm a little dizzy, love Dorothy."

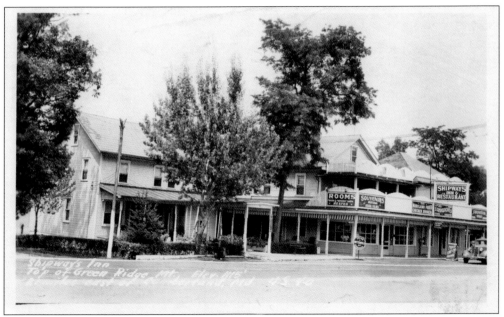

Shipway's was originally located on Green Ridge Mountain. It was established in 1921 and was a small stand that sold miscellaneous items. In 1923, Shipway's Everything was opened, and from this, Shipway's hotel, service station, motel, and restaurant soon followed. Located along U.S. Route 40, Shipway's Inn, as depicted above in 1948, boasted of rooms with heat and water and with or without bath. There were also delicious Maryland fried chicken dinners and souvenirs. In 1929, Shipway's Auto Camp also provided lovely two-room cottages.

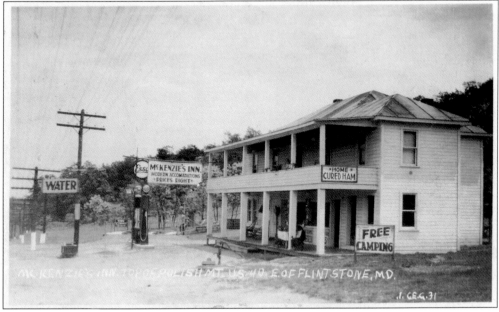

Postmarked August 3, 1931, this view depicts McKenzie's Inn atop Polish Mountain, U.S. 40 east of Flintstone. At McKenzie's Inn, you could count on free camping, water, home-cured ham, Esso gas, and modern accommodations "priced right." The sender of this card writes, "This is where we spent the night, Sam and Pearl."

DISCOVER THOUSANDS OF LOCAL HISTORY BOOKS FEATURING MILLIONS OF VINTAGE IMAGES

Arcadia Publishing, the leading local history publisher in the United States, is committed to making history accessible and meaningful through publishing books that celebrate and preserve the heritage of America's people and places.

Find more books like this at
www.arcadiapublishing.com

Search for your hometown history, your old stomping grounds, and even your favorite sports team.